The College History Series

SUNY
DOWNSTATE
MEDICAL CENTER

Shown is the logo of the SUNY Health Science Center at Brooklyn.

The College History Series

SUNY
DOWNSTATE
MEDICAL CENTER

JACK E. TERMINE

ARCADIA

Published by Arcadia Publishing,
an imprint of Tempus Publishing, Inc.
2 Cumberland Street
Charleston, SC 29401

Printed in Great Britain.

Library of Congress Catalog Card Number: 99-069492

For all general information contact Arcadia Publishing at:
Telephone 843-853-2070
Fax 843-853-0044
E-Mail sales@arcadiapublishing.com

For customer service and orders:
Toll-Free 1-888-313-2665

Visit us on the internet at http://www.arcadiapublishing.com

This pictorial monograph is dedicated to all the men and women who have passed through the various portals of what is known today as the State University of New York Health Science Center at Brooklyn. It is also dedicated to all the ancillary and essential staff who assisted these men and women in achieving their educational goals and professional dreams to tend to the nation's health care needs.

CONTENTS

ACKNOWLEDGMENTS

The idea for this monograph came about almost two years ago with the approaching 140th anniversary of Brooklyn's medical school. This work is specifically a tribute to that milestone. It is also a tribute to the school's 50-year affiliation with the State University of New York. The publication of this volume also coincides with the 10-year anniversary of the formal establishment of the archives here at the SUNY Health Science Center. Presented to the president of the Cabinet of the Health Science Center by the Division of Humanities in Medicine in 1989, the administrative body at that time saw the need and potential for such a facility. The subsequent federal and state grants further documented the rationale for such a repository in Brooklyn. Today, the facility not only documents the history of Brooklyn's medical school and Health Science Center, it also functions as a county repository, documenting the history of medicine, medical education, and health care in Kings County.

In my capacity as archivist of the medical center, I have served under several presidents: Dr. Donald Scherl, Dr. Richard Schwartz, Dr. Russell Miller, Dr. Eugene Feigelson, and now Dr. John LaRosa. I am grateful to all of these CEOs for their continued support. Today, the archives function as a department within the Medical Research Library of Brooklyn, under the direction of Dr. Richard M. Winant. I am thankful to Dr. Winant for his 10-year collegial association; he has allowed the institution's archives to flourish while others perish. His vision in the day-to-day operation of the library as a whole has not only enhanced the facility, but has also made assignments easier to perform. His commitment to the dissemination of information to the institution's clientele is paramount. I publicly salute him here. I am also indebted to those staff members at the Medical Research Library of Brooklyn with whom I work on a daily basis.

I am grateful for the scores of historical accounts, both published and unpublished, that were left to the archives. They have provided the basis for the story line and captions. I am indebted to the staff of the Department of Biomedical Communications for decades of photographic documentation of campus events and to the staff of the Department of Institutional Development for attaching the written word to those events. In these days of ever evolving computer programs, upgrades, internet communication, web-surfing scanning and digitizing, no one can handle the production of a project of this magnitude alone. So I thank Mr. Paul Moore for his patience and guidance in helping me to get this manuscript to the publisher in true computer style.

I thank Arcadia Publishing and, in particular, Pam O'Neil, my editor, for allowing this history to be portrayed, published, and distributed as part of their College History Series. It joins their outstanding school histories as well as other pictorial monographs. Last, but not least, I wish to acknowledge my parents, who have long supported me in my chosen career, for nourishing my interest in Brooklyn history. Their fond memories of Brooklyn's past will never cease to amaze me.

It is impossible to portray a 140-year history in 128 pages and 204 illustrations. Vast amounts of history have been necessarily omitted. Further, many historical facts could not be included because there was simply no documentation sent to the archives for permanent retention and verification. It is my wish that this brief history be used as a stepping stone for a more comprehensive historical account of the institution's accomplishments and contributions to American medicine in time for its sesquicentennial in 2010.

—J.E.T., Brooklyn, New York, 2000

INTRODUCTION

While the history of Downstate Medical Center has its roots with the Brooklyn German Dispensary in 1856, Brooklyn has a medical history dating back to the 1600s. An excellent synopsis has been written by Bessie Donaldson in her text *The Long Island College Hospital and Training School for Nurses*. It is reproduced here to set the stage for the history of Downstate Medical Center.

Perhaps, as an introduction, it would be fitting to retell something of the early history of Brooklyn and its development along medical lines up to 1860.

From the "History of the City of Brooklyn" in the Brooklyn Eagle file it is found that the first medical man in the village of "Breuckelen" was Dr. Paulus Van Der Beeck who arrived here in 1644.

There was so little sickness among the hardy Dutch settlers of those times that Dr. Van Der Beeck found little work in his profession and became a sort of jack of all trades, and later in his history is spoken of as "Dr. Paulus Van Der Beeck, surgeon and farmer". He prospered and grew rich, according to the chronicle, but it was not by physicing folks.

The second doctor to settle in the village was Gerardus Willemse Beekman, and he, it seems, combined two avocations now esteemed as highly profitable, "a physician and politician."

The fighting on Long Island during the Revolutionary war brought many army physicians and surgeons to Brooklyn and its vicinity, and they were indefatigable in relieving, as far as possible, the suffering of those confined in the temporary military hospitals established in private houses, churches and other buildings. At the close of the war a number of these physicians settled here, among them Dr. Beck who established himself in Flatbush, and Dr. John J. Barbarin and Dr. John Duffield who settled in Brooklyn.

From this period until the organization of the Kings County Medical society on April 2, 1822, the names of George Classman, Samuel Osborne, Charles Ball and Matthew Wendell are among those which appear prominently in the local records of the medical profession.

The town of Brooklyn in 1830 had a population of 15,295 and four years later was incorporated as a city. The Medical Society of Kings Count in 1830 had nineteen members upon its roll, and the town directory of that year indicates that there were about ten physicians engaged in the practice of medicine who were not connected with the Medical Society.

On the eighth of February, 1830, the first Dispensary in Brooklyn was organized at 168 Fulton Street, under the name of "The Brooklyn Dispensary."

It was left for Dr. Isaac J. Rapelyea, president of the Society in 1835, to make the first determined effort towards the permanent establishment of a hospital in Brooklyn. He urged the matter upon the attention of the Society in his

inaugural address delivered on July thirteenth of that year, and a memorial was presented to the City Council. It was without result, however, and not until five years later was a public place provided where immediate aid could be rendered to the injured. Then a few public-spirited citizens engaged physicians and surgeons to attend patients in a house located on Adams Street near Johnson, and owned by Cyrus P. Smith. On August 5, 1839, the Common Council appropriated two hundred dollars per annum for the support of this embryo hospital. In 1844, this appropriation was discontinued, but at a public meeting held on February seventh of the following year, a committee was appointed to provide for the incorporation of a hospital, and in the following May an act creating the Brooklyn city Hospital was passed by the Legislature. This is now know as the Brooklyn Hospital.

The early history of the Kings County Hospital appears to be intimately connected with the Brooklyn Almshouse. On April 9, 1832, the poorhouse at Flatbush was opened, and John B. Zabriskie, M.D. was appointed as physician at a salary of seventy dollars a year. In 1834, Dr. Zabriskie was re-appointed as physician. In 1838, the County Hospital and Lunatic Asylum were opened.

On February 8, 1848, Dr. J.B. Zabriskie died. He appears to have been the only physician connected the institutions up to this date.

About a year later the hospital at the Penitentiary was opened and T. Anderson Wade, M.D. was appointed physician. Dr. Wade agreed to treat all prisoners and furnish the necessary medicine for twelve dollars per month. Dr. Wade's salary was fixed in 1852 at two hundred and fifty dollars per annum. He remained physician at the Penitentiary for ten years.

In 1854 it became known to the Board of Superintendents that a bill was pending before the Legislature directing "that bodies of persons who may die in the poorhouse be delivered to medical schools for the purpose of dissection." The bill was denounced as a monstrous outrage, its provisions declared barbarous.

These were the conditions of Brooklyn's medical community in which Dr. Louis Bauer and his colleagues found themselves when they set out to establish their dispensary in 1856. The dispensary, which they would come call the Brooklyn German General Dispensary, would eventually become Brooklyn's sole institution for medical education in 1860. After 140 years of continuous operation, it is still Brooklyn's sole institution for undergraduate medical education. This is a chronicle of that institution.

One

THE FOUNDING OF AMERICA'S FIRST COLLEGE HOSPITAL

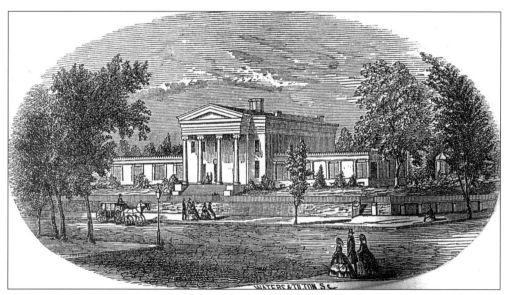

The Perry Mansion stood on Henry Street between Amity and Pacific Streets in Brooklyn. The Perry property was formerly part of the Ralph Patchen farm. The lots were purchased by Joseph A. Perry at various times; in 1835, he built the above residence. In 1843, the whole property was purchased by Dennis Perkins, who sold the property to the Long Island College Hospital on February 13, 1858 for the sum of $31,250.

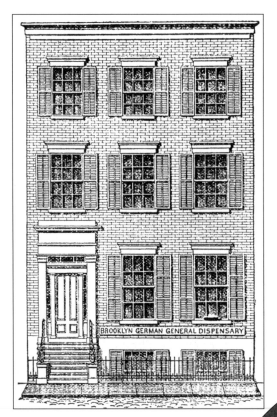

BROOKLYN GERMAN GENERAL DISPENSARY

In 1856, two German physicians—Gustav Braeunlich and Louis Bauer, a famous orthopedic surgeon and former member of the German Parliament—organized a charitable medical service known as the Brooklyn German General Dispensary. The dispensary was staffed by two additional physicians and a surgeon, as well as a cupper and leecher. Located at 132 Court Street, it was originally intended to provide medical care to the indigent German population. Meanwhile, the nationality of the local inhabitants was changing with an increase in Irish immigration.

Dr. Bauer (seen here) and Dr. Braeunlich were joined by other prominent Brooklyn physicians (including Dr. John Byrne and Dr. Daniel Ayers) in resolving to organize St. John's Hospital on October 27, 1857. The name was changed to the Long Island Hospital and Medical College on December 23, 1857. Careful scrutiny of the institution's *diarium* shows that the name "St. John's" was erased and written over by the words "Long Island." The word "College" was also inserted. An examination of the minutes proves that the institution was known as St. John's Hospital on November 7, 1857, while the term "Long Island College Hospital" does not appear until February 4, 1858.

Drs. Bauer, Byrne, and Dudley, the prime movers in the establishment of the medical college, were trained in Europe, where it was customary for medical schools to be associated with universities and hospitals. They seized upon the opportunity of starting a much desired medical school in Brooklyn by adopting that superior system of education as their model. In so doing, they founded the first medical school in America to be associated with a hospital. The charter was granted in March 1858. Daniel Ayers, M.D., is shown on the right.

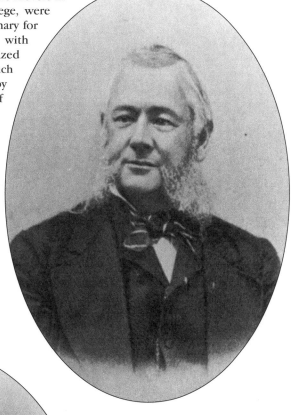

Almost immediately, the Perry Mansion, which was in the Heights section of Brooklyn, was purchased to house the new medical complex. It was a most imposing residence. The hospital was hit immediately with financial problems and was actually forced to close. The regents took steps to liquidate the affairs of the institution and looked to sell the property at public auction. It was Dr. William H. Dudley who purchased the property at auction and who would yield title to the property until May 11, 1865, at which time he was reimbursed and the title transferred back to the regents. Meanwhile, the collegiate division performed a national search for a first-rate faculty. John Byrne, M.D., is pictured on the left.

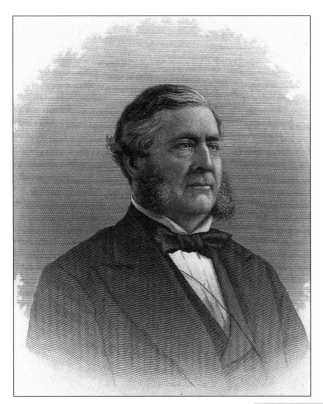

The institution reopened with an evening lecture on Thursday, March 29, 1860. Classes started the next day. An account of the evening's events was recorded in the *Brooklyn Daily Eagle*. Dr. Theodore L. Mason made an address in which he gave a brief history and stated the objectives of the institution. In the course of his remarks, he pointed out the beneficial effect that such an institution would have upon the city. All this said and done, Brooklyn's medical school was born. William H. Dudley, M.D., is pictured on the left.

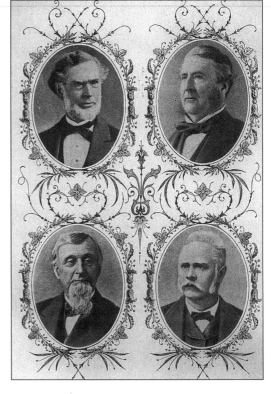

The first council in 1858 included the following physicians, from left to right: (top row) Chauncey L. Mitchell, M.A., M.D., and William H. Dudley, Ph.D.; (bottom row) Theodore L. Mason, M.D., and John Byrne, M.D., LL.D.

Austin Flint, M.D., a professor of practical medicine and pathology, was the most eminent member of the faculty. Dr. Flint came from a medical family of four generations. He graduated from Harvard in 1833 and began practicing medicine in Boston. He then moved to Buffalo, where he became a founding member of the first faculty of the Buffalo Medical College and the founder and editor of the *Buffalo Medical Journal*. Later, he became a professor of medicine at Louisville University Medical School. He subsequently moved to the Medical College of New Orleans, where he remained a professor of clinical medicine before he began teaching in Brooklyn in 1860. Dr. Flint was one of the most significant influences in New York medicine in the second half of the 19th century. He had acquired an international reputation based on his extensive medical writings and his contributions to the physical diagnosis and diseases of the heart and lungs. He did more than anyone in this country to bring the stethoscope into general use in regular examinations by illustrating its value in identifying heart and lung disease. Flint earned the title "the American Laennec," after the French physician who invented the stethoscope and who perfected the art of diagnosis through careful comparison of physical findings and autopsy results. Flint helped round out the work of Laennec with his detailed analysis of the sounds produced by tapping the chest and the sounds of breathing as heard through the stethoscope. His articles "Cardiac Murmurs" and "An Analytical Study of Auscultation and Percussion" are basic medical classics. He furthered the study of tuberculosis by his clear description of the earliest signs of its involvement in the lungs. He also discovered and described a murmur of great diagnostic value in valvular heart disease, known today as the "Austin Flint Murmur."

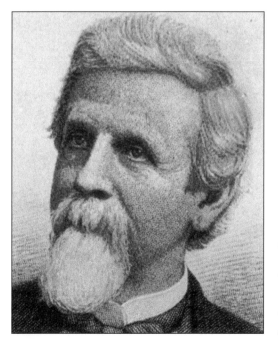

Dr. James D. Trask, professor of obstetrics and diseases of women and children, was a founder of the American Gynecological Society and was widely known for his clinical skill. A 1939 graduate of Amherst College, he received his medical degree from the University of the City of New York in 1844 and later received an honorary M.D. degree from the Medical College of Buffalo. His paper entitled "Placenta Praevia" was published as the prize essay in the 1855 *Transactions of the American Medical Association*.

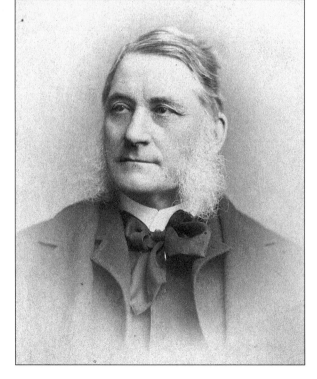

Dr. Frank H. Hamilton, professor of surgery, was a graduate of the University of Pennsylvania Medical School. He taught surgery at Fairfield College of Physicians and Surgeons and later at Geneva Medical College. With Austin Flint, he was a founder of the Buffalo Medical College, where he taught for 12 years until he came to Brooklyn in 1860. By this time, he was already well known as an authority on the treatment of fractures. His *Treatise on Fractures and Dislocations* was the first complete work on the subject in English. It was printed in seven editions and translated into French and German. In 1847, while still in Buffalo, Hamilton was the first to advocate skin grafting. With the outbreak of the Civil War in 1861, Hamilton entered the U.S. Army as a volunteer regimental surgeon. The following year, he published his elaborate and comprehensive "Treatise on Military Surgery and Hygiene." On February 9, 1863, he was appointed Medical Inspector of the U.S. Army with the rank of lieutenant colonel. Returning to the Long Island College Hospital later in 1863, he was appointed to the chair of military medicine, the first department of its kind to be established in this country. In 1871, under the direction of the U.S. Sanitary Commission, he edited the *Surgical Memoirs of the War of the Rebellion.*

Dr. Joseph C. Hutchison, professor of surgical anatomy and operative surgery, was a distinguished Brooklyn surgeon. A graduate of Jefferson Medical College and the Medical Department of the University of Pennsylvania, he was on the staff of the Brooklyn City Hospital. For a number of years, he was a member of the Brooklyn Orthopedic Infirmary, which he founded. During the cholera epidemic of 1845, he had been physician-in-charge of the Brooklyn Cholera Hospital and later, from 1873 to 1875, he served as medical head of the Brooklyn Board of Health.

Dr. John Call Dalton, professor of physiology and microscopic anatomy, was the most renowned physiologist in America at this time. Educated at Harvard University, he received his M.D. degree in 1847 and later spent several months in Paris studying under the noted French physiologist, Claude Bernard. Upon his return, he taught physiology at Boylston Medical School and at the Vermont and Buffalo Medical Colleges, leaving the latter in 1860 to join the faculty in Brooklyn. As a demonstrator and teacher, Dr. Dalton had few equals. He was present at one of the first demonstrations of the use of ether anesthesia and immediately started using ether in his own animal experiments. He was the first in this country to teach physiology by conducting experiments on animals in front of his students. He was a prolific writer; his essay "Corpus Luteum of Pregnancy" won the American Medical Association prize in 1859 and immediately established his reputation as an able investigator and original physiologist. His *Treatise on Human Physiology*, first published in 1859, was a standard textbook in American medical schools for two decades.

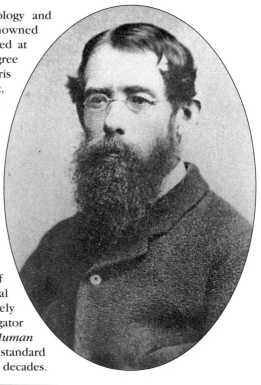

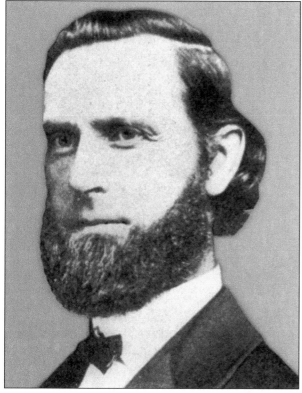

Dr. DeWitt Clinton Enos, professor of general and descriptive anatomy, was also on the staff of the Brooklyn City Hospital. A graduate of the College of Physicians and Surgeons, he was the writer of a number of clinical papers, chiefly on surgical topics. In 1867, he became professor of operative and clinical surgery at the Long Island College Hospital.

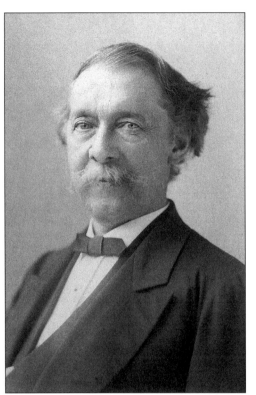

Dr. R. Ogden Doremus, professor of chemistry and toxicology, was probably the foremost toxicologist in America in the mid-19th century and made newspaper headlines more than once by giving expert testimony at murder trials. A native of New York City, Dr. Doremus received his medical degree from the University of the City of New York in 1851 and then served as professor of chemistry at New York College of Pharmacy for several years. He was one of the founders of New York Medical College and was dean there during his three-year tenure on the faculty in Brooklyn. Dr. Doremus was a speaker of great skill and charm who delivered many popular lectures to Brooklyn audiences on chemistry, physics, and other scientific subjects.

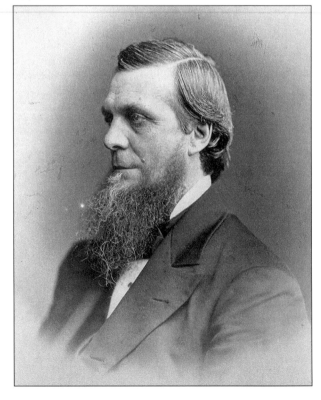

Dr. Edwin N. Chapman, professor of *materia medica* and therapeutics, was a graduate of Jefferson Medical College. He later succeeded Dr. Trask as the chair of the Department of Obstetrics and Diseases of Women and Children. He became one of the elder statesmen of the college, serving on the joint board of the council and faculty and, later, on the board of regents.

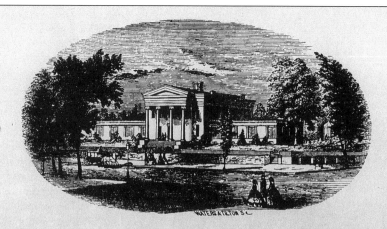

Long Island College Hospital,

OF BROOKLYN, NEW YORK.

THE FIRST COURSE OF LECTURES

IN THIS INSTITUTION,

WILL BE COMMENCED ON THURSDAY, MARCH 29, 1860,

AND CONTINUE SIXTEEN WEEKS.

BOARD OF REGENTS:

HON. SAMUEL SLOAN, President.

LIVINGSTON K. MILLER, Esq., Secretary.

COUNCIL:

T. L. MASON, M. D. C. L. MITCHEL, M. D.

WM. H. DUDLEY, M. D. J. H. HENRY, M. D.

PROFESSORS:

AUSTIN FLINT, M. D., (New-Orleans School of Medicine,) Professor of Practical Medicine and Pathology.

FRANK H. HAMILTON, M. D., (University of Buffalo,) Professor of Surgery.

JAMES D. TRASK, M. D., Professor of Obstetrics and diseases of women and children.

R. OGDEN DOREMUS, M. D., (New-York Medical College,) Professor of Chemistry and Toxicology.

JOSEPH C. HUTCHISON, M. D., Professor of Surgical Anatomy and Operative Surgery.

JOHN C. DALTON, M. D., (Coll. of Physicians and Surgeons, N. Y.) Prof. of Physiology and Microscopic Anatomy.

DE WITT C. ENOS, M. D., Professor of General and Descriptive Anatomy.

EDWIN N. CHAPMAN, M. D., Professor of Materia Medica and Therapeutics.

DEMONSTRATOR OF ANATOMY:

J. G. JOHNSON, M. D.

This announcement declared that the first course of lectures commenced on March 29, 1860. Fees for the whole course included the following: matriculation, $100; a single ticket, $12.50; graduation fee, $20; and a demonstrator's ticket, $5. Upon payment of $5, regular physicians would be admitted to all the lectures.

The candidate for graduation was required to have studied medicine for three years under the direction of a regular practitioner and had to have two full courses of lectures, one of which had to be at the Long Island College Hospital. A graduate also had to be 21 years of age, of good moral character, and had to submit to the faculty a thesis in his own handwriting on some medical subject.

The first diploma issued by the Long Island College Hospital was issued to Arthur DuBerceau of the Class of 1860. Graduates were presented by Dr. William H. Dudley, registrar. Dr. Mason, the president of the Collegiate Department, conferred the degrees. DuBerceau stated in his will that upon his death, his diploma should be returned to his alma mater.

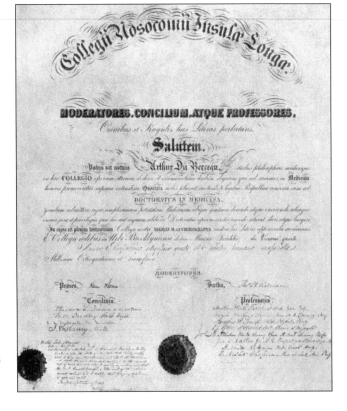

AN ADDRESS:

DELIVERED TO THE GRADUATES

OF THE

LONG ISLAND COLLEGE HOSPITAL,

BROOKLYN, N. Y.,

AT THE

ANNUAL COMMENCEMENT,

ON THE

EVENING OF JULY 24th, 1860,

BY

AUSTIN FLINT M. D.,

PROFESSOR OF PATHOLOGY AND PRACTICAL MEDICINE IN THE LONG ISLAND COLLEGE HOSPITAL ;
AND OF CLINICAL MEDICINE AND PATHOLOGY IN THE NEW ORLEANS SCHOOL OF MEDICINE.

PUBLISHED BY THE GRADUATING CLASS.

Brooklyn:

WILTON, BOOK AND JOB PRINTER, CORNER COURT AND JORALEMON STS,

1860.

The first commencement took place on July 24, 1860, in the chapel of the Packer Institute, a girls' school that is still located on Joralemon Street in Brooklyn. The opening prayer was offered by the Reverend Richard S. Storrs of the Church of the Pilgrims. The commencement address was delivered by Dr. Austin Flint. The degree of Doctor of Medicine was conferred on 21 graduates.

CIRCULAR AND CATALOGUE,

OF THE

Long Island College Hospital,

BROOKLYN, N. Y.

SESSION FOR 1861.

A PRELIMINARY COURSE OF LECTURES WILL BE COMMENCED FEBRUARY 18TH.

THE REGULAR COURSE OF LECTURES WILL BE COMMENCED MARCH 18TH, 1861.

BOARD OF REGENTS:

HON. SAMUEL SLOAN, PRESIDENT,
THOS. H. RODMAN, ESQ., SECRETARY.

COUNCIL:

T. L. MASON, M.D. C. L. MITCHELL, M.D.
WM. H. DUDLEY, M.D. J. H. HENRY, M.D.

PROFESSORS:

AUSTIN FLINT, M.D., (New Orleans School of Med.,) Prof. of Practical Med. and Pathology.
FRANK H. HAMILTON, M.D., (University of Buffalo,) Professor of Surgery.
JAMES D. TRASK, M.D., Prof. of Obstetrics and diseases of women and children.
R. OGDEN DOREMUS, M.D. (N.Y. Medical College,) Professor of Chemistry and Toxicology.
JOSEPH C. HUTCHISON, M.D., Professor of Operative Surgery and Surgical Anatomy.
JOHN C. DALTON, Jr., M.D., (Coll. of Physicians and Surgeons, N.Y.,) Prof. of Physiology, and Microscopic Anatomy.
DEWITT C. ENOS, M.D., Professor of General and Descriptive Anatomy.
EDWIN N. CHAPMAN, M.D., Professor of Therapeutics and Materia Medica.

GEO. K. SMITH, M.D., Demonstrator of Anatomy.
A. W. WILKINSON, M.D., Assistant to Prof. of Chemistry.
A. DUNCAN WILLSON, M.D., Prosector to Professor of Operative Surgery.

FACULTY OF THE HOSPITAL:

Physicians: Surgeons:
E. M. CHAPMAN, M.D., FRANK H. HAMILTON M.D.
WM. HEUSER, M.D.
 Adjuncts:
WM. H. DAVOL, M.D., J. G. JOHNSON, M.D.
J. E. CLARK, M.D., D. H. DODGE, M.D.,
A. HALLETT, M.D. WM. GH.FILLAND, M.D.
 P. C. PEASE, M.D., H. P. and surgeons.

WILTON, Printer, cor. Court and Joralemon sts., Brooklyn.

In 1861, a preliminary one-month course beginning February 18 was added to the curriculum. This course was devoted chiefly to lectures by Dr. Frank H. Hamilton on military surgery. The Civil War was imminent and the medical schools were preparing to meet the needs of the nation.

Following President Lincoln's proclamation of war, most of the early graduates of the school volunteered. Nearly as many served with the South as with the North. The war was uppermost in the minds of the students, the faculty, and the doctors. Several members of the faculty also enlisted. The facilities of the hospital were immediately placed at the disposal of the wounded, and the wards were filled with soldiers. In 1862 alone, 211 wounded soldiers were treated.

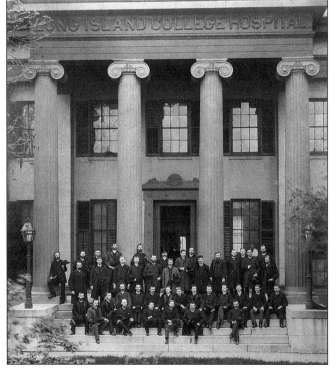

Two

THE EARLY YEARS

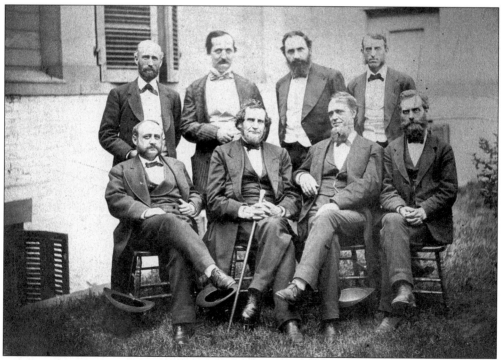

These early faculty members were photographed *c.* 1873. They are, from left to right, as follows: (standing) George W. Plympton, A.M., professor of chemistry and toxicology; William W. Greene, M.D., professor of the principles and practice of surgery and clinical surgery; Alexander J.C. Skene, M.D., professor of the medical and surgical diseases of women and diseases of children; and Joseph H. Raymond, M.D., professor of physiology and microscopic anatomy; (sitting) Edward S. Dunster, M.D., professor of obstetrics and diseases of children; Corydon L. Ford, M.D., professor of anatomy; Samuel G. Armor, M.D., LL.D., professor of the principles and practice of medicine and clinical medicine and dean of the faculty; and Jarvis S. Wight, M.D., professor of the principles and practice of surgery and clinical surgery and registrar.

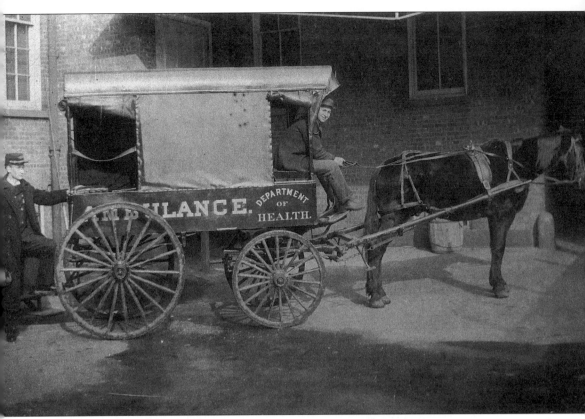

The hospital started an ambulance service in 1871 with an ambulance donated from the City of New York. The Brooklyn ambulance service was formally established on August 20, 1873, incorporating the Long Island College Hospital's ambulance for service to the western district of the city. A depot near the Eastern District Hospital was added to service that part of the city. The total number of calls for both ambulances in the service's first written report of January 1, 1875 was 770, and the total number of patients removed to hospitals or to their homes was 687.

The first major change in teaching occurred in 1869, when an optional reading and recitation term was added. This term began late in October and extended to the regular term in March. Taught chiefly by junior men on the staff, it provided "a more systematic training in the primary before passing to the more advanced practical branches." In 1879, the regular term was lengthened from 16 weeks to 5 months. Any student who desired advanced training could obtain it by electing two regular and two reading and recitation terms, thus receiving 18 months of instruction overall. The individual courses were flexible enough so that nobody had to sit through the same course twice. The curriculum at the college permitted a student to take three years of instruction, lasting six months a year, without repeating any courses. At this time, no medical school in the country offered more instruction.

Long Island College Hospital,
BROOKLYN, N.Y.

Annual Announcement and Circular,
1877-78.

The READING AND RECITATION TERM will commence October 4, 1877, and close Feb. 14, 1878.
The REGULAR TERM will open March 5, 1878, and close the last week in June following.

COUNCIL.

T. L. MASON, M.D.,
President Collegiate Department.
C. L. MITCHELL, M.D.,
Secretary.

WM. H. DUDLEY, M.D.,
J. SULLIVAN THORNE, M.D.

FACULTY OF THE COLLEGE.

DANIEL AYRES, M.D. LL.D.,
Emeritus Professor of Surgical Pathology and Clinical Surgery.
SAMUEL G. ARMOR, M.D. LL.D.,
Professor of the Principles and Practice of Medicine and Clinical Medicine, and Dean of the Faculty.
GEORGE W. PLYMPTON, A.M.
Professor of Chemistry and Toxicology.
ALEXANDER J. C. SKENE, M.D.,
Professor of the Medical and Surgical Diseases of Women, and Diseases of Children.
GEORGE K. SMITH, M.D.,
Lecturer on Venereal Diseases.
J. S. PROUT, M.D.,
Lecturer on Diseases of the Eye.
ARTHUR MATHEWSON, M.D.,
Lecturer on Diseases of the Ear.
LEWIS D. MASON, M.D.,
Lecturer on Surgical Anatomy.
FREDERICK H. COLTON, M.D.,
Demonstrator of Anatomy.
LEWIS S. PILCHER, M.D.,
Lecturer Adjunct to Chair of Anatomy.
SAMUEL SHERWELL, M.D.,
Lecturer on Diseases of the Skin.
THOMAS R. FRENCH, M.D.,
Lecturer on Laryngoscopy, and Diseases of the Throat.

CORYDON L. FORD, M.D.
Professor of Anatomy.
JARVIS S. WIGHT, M.D.,
Professor of the Principles and Practice of Surgery and Clinical Surgery, and Registrar.
JOSEPH H. RAYMOND, M.D.,
Professor of Physiology and Microscopic Anatomy.
EDWARD SEAMAN BUNKER, M.D.,
Professor of the Principles and Practice of Obstetrics, and Clinical Obstetrics.
JOHN D. RUSHMORE, M.D.,
Professor of Materia Medica and Therapeutics.
HENRY N. READ, M.D.,
Assistant to the Chair of Diseases of Children.
GEORGE H. ATKINSON, M.D.,
Assistant to the Chair of Practice, and Senior Assistant Demonstrator of Anatomy.
JOHN A. McCORKLE, M.D.,
Assistant to the Chair of Practice.
GEORGE W. CUSHING, M.D.,
Assistant to the Chair of Diseases of Women.
EDWARD J. HARVEY, M.D.,
Assistant to the Chair of Surgery.
BENJAMIN F. WESTBROOK, M.D.,
Junior Assistant Demonstrator of Anatomy.
JEROME WALKER, M.D.,
Assistant to the Chair of Diseases of Children.

FACULTY OF READING TERM.

JARVIS S. WIGHT, M.D.,
Lecturer on Physical Science.
JOSEPH H. RAYMOND, M.D.,
Lecturer on Histology.
EDWARD S BUNKER, M.D.,

LEWIS S. PILCHER, M.D.,
Lecturer on Anatomy.
JOHN A. McCORKLE, M.D.,
Lecturer on the Principles of Medicine.
THOMAS R. FRENCH, M.D.,

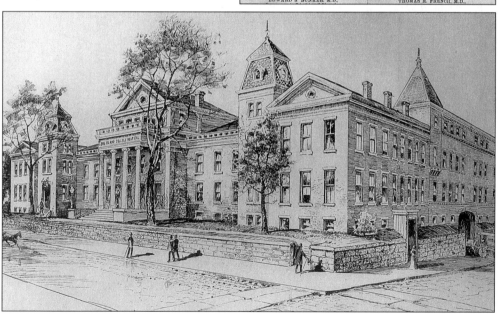

The annual announcement for 1880 stated that in order to graduate, the student must pass oral and written examinations in chemistry, anatomy, histology, physiology, *materia medica*, therapeutics, gynecology, obstetrics, surgery, and the practice of medicine. The other requirements for graduation remained the same: three years of study with a physician of good standing and attendance at two courses of lectures. It became evident that time spent developing a thesis could be better utilized by studying clinical medicine. Therefore, the thesis requirement was dropped in 1882. Enhancements to the physical plant allowed students to take advantage of new curriculum offerings. Above, Long Island College Hospital is shown as it appeared *c.* 1883.

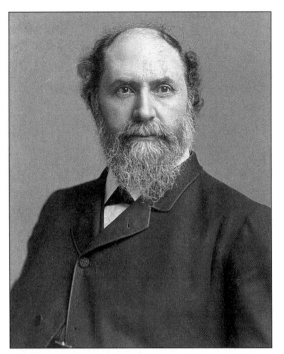

One of the college's most famous alumni was Dr. Alexander J.C. Skene. Born in Aberdeenshire, Scotland, in 1838, he came to America at the age of 19 and graduated from the Long Island College Hospital in 1863. After serving in the Civil War, he entered private practice in Brooklyn in 1864. Within a year, he had begun his college and hospital work in obstetrics at the Long Island College Hospital. He was named professor of diseases of women and clinical obstetrics in 1870, devoting the remaining 31 years of his life to the college hospital as teacher, physician, dean of the faculty from 1886 to 1892, and president of the college from 1893 to 1899. In 1880, he also founded the Long Island College Hospital Alumni Association.

THE ANATOMY AND PATHOLOGY OF TWO IMPORTANT GLANDS OF THE FEMALE URETHRA.

BY

ALEX. J. C. SKENE, M.D.,

Professor of Gynecology in the Long Island College Hospital, Brooklyn, New York.

(With lithographic plate.)

UPON each side near the floor of the female urethra, there are two tubules large enough to admit a No. 1 probe, of the French scale. They extend from the meatus urinarius up-

Skene's name has survived in medical texts, as shown above in the *American Journal of Obstetrics* of 1880, as the discoverer of two small mucous-secreting glands located in the floor of the urethra, known today as "Skene's Ducts." Often the seat of infection, these glands had been a source of intractable trouble up to the time of their recognition by Skene. Dr. Skene also devised many new medical and surgical instruments; he is remembered today as the inventor of a special glass self-retaining catheter for the female bladder, known as "Skene's Catheter." Dr. Skene became a recognized authority on women's diseases. His *Treatise on Diseases of Women*, first published in 1888, was the outstanding work on this subject in America for years. He was one of the founders of the American Gynecological Society and the founder and honorary president of the International Congress of Gynecology and Obstetrics. Dr. Skene is memorialized at Grand Army Plaza, Prospect Park, with a bronze bust; his statue is the only tribute to a physician in Brooklyn in a public park.

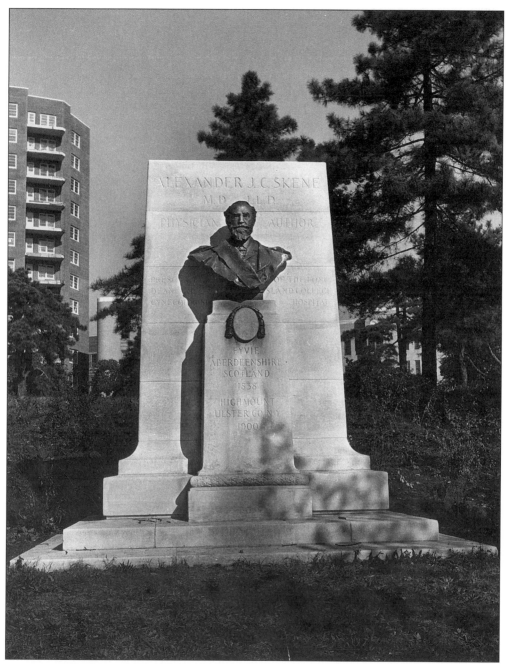

On May 25, 1880, in response to an invitation sent by a self-constituted committee, the Association of Alumni of Long Island College Hospital was formed. Dr. Alexander Skene was voted first president. At a second meeting on June 8, 1880, Dr. Skene offered a prize of $100 to the alumnus who wrote the best essay on a medical subject. The prize-winning essay was read at the first annual meeting held at the college on June 13, 1881. After the meeting, the association adjourned to the historic landmark, the Iron Pier at Coney Island, where the first annual alumni dinner was served to 150 members and guests. Since then, the association has held an annual meeting and dinner dance.

Questions in Physiology.
1888.

1. Name the five classes of physiological ingredients, giving the characteristics of one member of each class.

2. Describe gastric digestion.

3. Describe the adult and fœtal circulations, mentioning the main points of difference between the circulatory apparatus of the fœtus and that of the adult.

4. Describe the functions of the fifth pair of nerves.

5. Describe the ovum, its fecundation and segmentation.

During the latter part of the 19th century, the standards of medical education were raised by the New York State Legislature. After 1893, students entering medical school had to obtain a Medical Student's Certificate from the regents of the university of the State of New York. The certificate verified that they had either passed the regents' examinations in specified subjects or had attended at least three years at an accredited high school. This image shows an 1888 examination as part of the introductory physiology course.

1889.
EXAMINATION IN HISTOLOGY.

1. Give the varieties of epithelium lining the different parts of the uriniferous tubules.
2. Name the different coats of the intestines and give the course of the fibers in the muscular coats.
3. Give the histological composition of the mucous membrane of the small intestine.
4. Where is columnar ciliated epithelium found in the human body?
5. What are the points of difference, under the microscope, between white and yellow elastic fibrous tissues?
6. Give the columns and pyramids of the kidneys, and the variety of tubules found in these.
7. What is the difference between the structure of the walls of small and large arteries?

The entering class of 1897 began a four-year graded course. The reading term was abolished and the school year lasted seven months. During the same year, the educational requirements for a Medical Student's Certificate were increased to a minimum of four years in an accredited high school. This image shows an 1889 examination as part of the basic histology course.

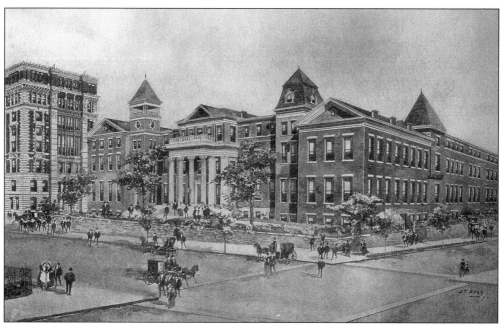

This rendering of the Long Island College Hospital grounds shows the Polhemus Memorial Building, built as a memorial to Henry Ditmas Polhemus by his wife. The new Maxwell Memorial, built in honor of Mr. Henry W. Maxwell, can also be seen. The new hospital building would be built as distinct but connected structures designated A, B, C, and D. This plan allowed for the reconstruction of a new hospital on the site of the existing hospital.

Course admission tickets were necessary to attend classes. A matriculation ticket was similar to the present-day student identification card.

Dr. Austin Flint Jr., the son of the professor of medicine, succeeded Dr. John C. Dalton as the chair of physiology in 1863. A graduate of Jefferson Medical College, he began practice with his father in Buffalo in 1857. He later taught physiology at Buffalo University Medical School and at the New Orleans School of Medicine. In 1861, at the age of 25, he moved to New York, where he became one of the founders of the Bellevue Hospital Medical School and served as professor of physiology for almost 30 years. Dr. Flint was an assistant surgeon in the U.S. Army at the New York General Hospital during the Civil War and later served as the surgeon general of the State of New York. In 1878, he was appointed to the consulting board of the New York City Lunatic Asylum; he later became president of its medical board. From this time until his death, he took a great interest in psychiatry and became one of the noted experts in mental disease in New York. He was often associated with important medico-legal cases that came before the courts of the state. A prolific writer, Dr. Flint is best known for his five-volume *Physiology of Man*.

Dr. William C. Lusk succeeded Austin Flint Jr. as professor of physiology in 1869. He had obtained his M.D. degree at Bellevue Hospital Medical College in 1864 and then studied abroad for three years. Returning to America, he settled in New York, where he became one of the leading obstetricians. In 1871, he divided his time between the Long Island College Hospital and Harvard, where he lectured in physiology at the invitation of Dr. Oliver Wendell Holmes. Later that year, he accepted the chair of obstetrics and diseases of women and children at the Bellevue Hospital Medical College. He held that position until his death. Lusk became widely known for his many contributions to obstetrics. In 1887, he performed the second successful Caesarean section in New York City, the first having been done in 1838. His celebrated *Science and Art of Midwifery* was the first attempt of a textbook in English to explain gestation and labor in accord with physiological laws. The book went through four editions and was translated into French, Spanish, Italian, and Arabic.

Dr. Corydon L. Ford succeeded Dr. Enos as professor of anatomy in 1868. He was known as the greatest teacher of anatomy in America at that time. In 1846, four years after his graduation from Geneva Medical College, he had taken an active part with Flint and Hamilton in establishing the Medical College at Buffalo. For three years, he served as a demonstrator in anatomy at both Geneva and Buffalo, often giving lectures in the place of the professor and establishing his reputation as an expert teacher. In 1854, he became professor of anatomy in the department of medicine and surgery at the University of Michigan. He did not practice medicine as was customary among his colleagues, but taught anatomy full time and without interruption for 52 years. He taught at the University of Michigan for 40 years and concurrently at the Long Island College Hospital for 18 years. He resided in Ann Arbor in the fall and winter months and in Brooklyn in the spring and early summer.

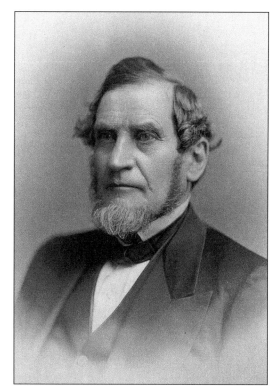

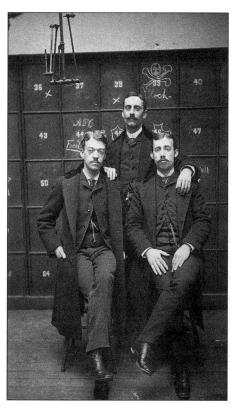

Students from the Class of 1887 included, from left to right, an unidentified student, Dr. Frank Hinchman Clark (standing), and Dr. William Simons Overton.

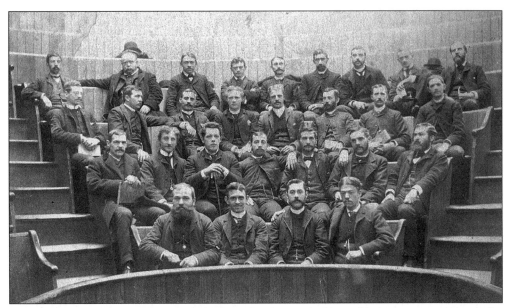

The Class of 1887 poses in the lecture hall. Notice the amphitheater-like seating arrangement for viewing clinical cases and demonstrations.

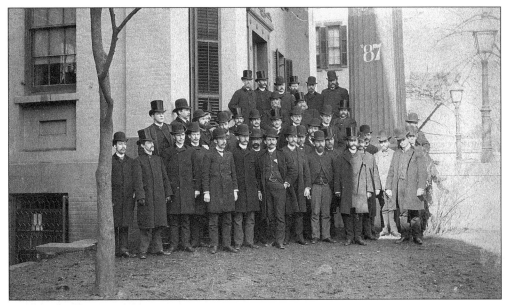

All classes took a group photograph in front of the Long Island College Hospital. Note the class year marked in chalk on the column.

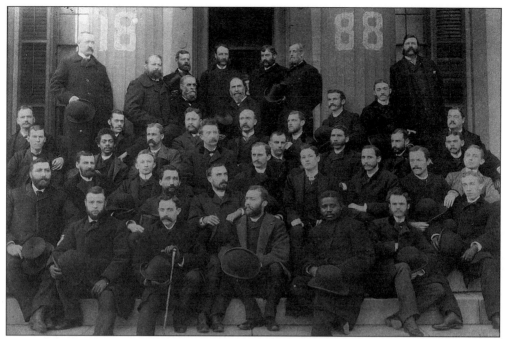

The members of the Class of 1888 take their turn on the portico of the Long Island College Hospital. Again, note the year 1888 marked in chalk on the columns.

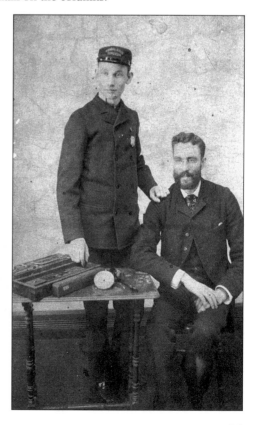

Two students sit for a formal photograph.

READING AND RECITATION TERM—1892.

	MONDAY.	TUESDAY.	WEDNESDAY.	THURSDAY.	FRIDAY.	SATURDAY.
9 A.M.			Obstetrics, Dr. Dickinson.		Obstetrics, Dr. Dickinson.	
10 A.M.	Materia Medica, Dr. Gunther.	Principles of Medicine, Dr. De La Vergne.	Materia Medica, Dr. Gunther.	Histology and Pathological Anatomy, Dr. Van Cott.	Principles of Medicine, Dr. De La Vergne.	Histology and Pathological Anatomy. Dr. Van Cott.
11 A.M.	Anatomy, Dr.W.W.Browning	Physical Diagnosis, Dr. Hall.	Anatomy, Dr.W.W.Browning	Physical Diagnosis, Dr. Hall.	Anatomy, Dr.W.W.Browning	
1 P.M.	Clinics, Hospital and Dispensary.	Clinics, Hospital and Dispensary.	Clinics, Hospital and Dispensary.	Clinics, Hospital and Dispensary.	Clinics, Hospital and Dispensary.	
2 P.M.	Medical Clinic, Prof. McCorkle.	Clinic for Diseases of Women, Prof. Skene.	Surgical Clinic, Prof. Wight. 2 to 3:30 P. M.	Clinics for Diseases of Children, Prof. Read.	Medical Clinic, Prof. West.	
3 P.M.	Diseases of Children, Prof. Bartley.	Chemistry, Dr. Hutchinson.	Gynecology, Dr. Cushing. 3:30 to 4:30 P. M.	Chemistry, Dr. Hutchinson.	Chemistry, Dr. Hutchinson.	
4 P.M.	Physiology, Prof. Raymond.	Principles of Surgery, Prof. Rand.	Physiology, Prof Raymond. 4:30 to 5:30 P. M.	Principles of Surgery, Prof. Rand.	Anatomy and Physiology of the Nervous System, Dr.W.W.Browning	

Practical Anatomy, in Dissecting Room, every evening (except Saturday), until May 1, from 8 to 10 P. M. Dr. Wm. W. Browning, Demonstrator.

This 1892 schedule included a reading and recitation term.

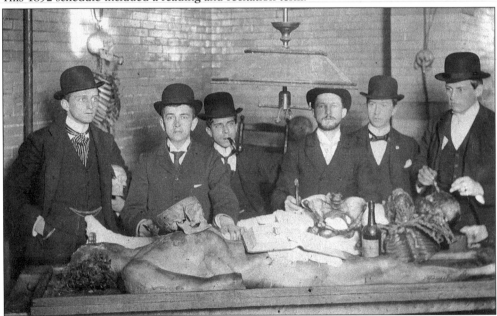

Members of the Class of 1897 appear in the basement laboratory of the Hoagland Laboratory, c. 1896. The laboratory was equipped for upperclassmen who wished to review their anatomy by dissection. Seen here, from left to right, are Andrew G. Foord, Charles T. Estabrook, Harry W. Nichols, Benjamin A. Barney, William A. Jewett, and Cornelius B. Love.

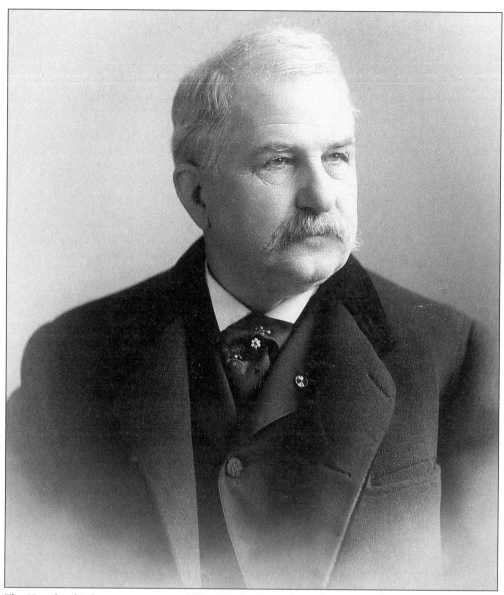

The Hoagland Laboratory was opened across the street from the Long Island College Hospital in the fall of 1888. The laboratory was built in an era when the discoveries of Pasteur and Koch were beginning to revolutionize medical thought and disclose the true causes of infectious disease. It was originally intended by its founder to be a place for bacteriology research. Later, because of the need for teaching in this new science, the laboratory would also be used for teaching bacteriology to special and advanced students. The possibility of offering this course to the medical students was not considered since no medical school in the country at that time taught bacteriology to undergraduates. It was decided that the laboratory would be built near the Long Island College Hospital so that undergraduate medical courses in the older basic sciences, such as histology, pathology, and physiology, could also be taught there. The Hoagland Laboratory was built and endowed by Dr. Cornelius N. Hoagland, seen here, who was a regent of the Long Island College Hospital at that time.

When completed, the Hoagland Laboratory was generally regarded as one of the finest and best-equipped buildings for medical teaching and research in the country. The October 7, 1888 issue of the *Brooklyn Daily Eagle* said, "The Hoagland Laboratory is one of the most complete [medical school laboratories] in the country. The Johns Hopkins University in Baltimore has one, but the large expenditure of money required to procure such an auxiliary has placed it beyond the possibility of many medical colleges." A graduate of the Medical Department of Western Reserve University, Dr. Hoagland served as an officer with an Ohio regiment during the Civil War. He returned to Brooklyn in 1868 to enter business life; with his brother, he built up a successful business with the formula for Royal baking powder by advertising directly to the consumer. Retiring from business in 1876, Hoagland devoted his time and money to educational and philanthropic ends. He was an accomplished microscopist and an expert photographer, especially skilled in photomicrography. In the organization of the laboratory, he became director of the Department of Photomicrography as well as president of the board.

Dr. George M. Sternberg was the first director of the Hoagland Laboratory. He was probably America's foremost bacteriologist at the time and already known throughout the world for his researches on disinfection, malaria, and yellow fever. A graduate of the College of Physicians & Surgeons in New York City, Dr. Sternberg entered the U.S. Army in 1861 at the age of 23. During his service, he became interested in yellow fever. His article "A Study of the Natural History of Yellow Fever," published in 1877, earned him the status of an authority on the subject. In 1879, he was detailed for duty with the Havana Yellow Fever Commission. Sternberg's research on yellow fever extended over a quarter of a century. His work became an essential part of the series of investigations that finally led to the discovery of the cause of yellow fever and the development of methods for its prevention. These later studies were conducted under Dr. Walter Reed by the Army Yellow Fever Commission, appointed by Sternberg during his administration as surgeon general.

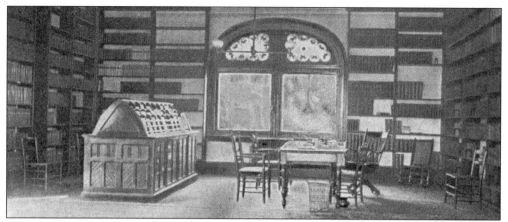

In 1881, Dr. Sternberg discovered the pneumococcus in his own saliva, although he did not know at the time that it was the cause of lobar pneumonia. He was the first man in America to demonstrate the tubercle bacillus (1881), the living motile plasmodium of malaria (1885), and the bacillus of typhoid fever (1886). He was a pioneer immunologist, inquiring as early as 1881 into the nature of immunology to infectious diseases. Beginning in 1878 and for many years thereafter, he made a thorough study of disinfectants and methods of disinfection; the scientific standardization of disinfection and methods of its use were largely based on these investigations. In the fall of 1890, Sternberg, a major in the U.S. Army, was ordered to San Francisco for duty and was given a one-year leave of absence from the Hoagland Laboratory. During this period, he wrote his *Manual of Bacteriology*, a 900-page volume that was the most extensive treatment of the subject in the English language. The Hoagland Library is pictured above.

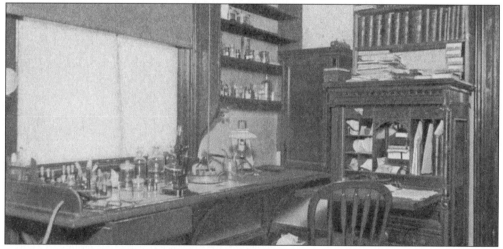

Sternberg returned to Brooklyn in May 1892. He had been promoted to lieutenant colonel and was assigned to be examiner of recruits in the Army Building on lower Broadway. He and Mrs. Sternberg lived at the St. George Hotel in Brooklyn and during the next two years, he devoted considerable time to the Hoagland Laboratory. Sternberg learned on May 30, 1893, that he had been appointed the surgeon general of the U.S. Army. He submitted his resignation as director of the Hoagland Laboratory to take effect the following September. Before he left Brooklyn, during the summer of 1893, Sternberg sent one of his assistants to Chicago to help set up the U.S. War Department's medical exhibit at the World's Fair. Among the exhibits shown were photomicrographs of bacteria made by Cornelius Hoagland. This individual workroom was provided in the Department of Bacteriology.

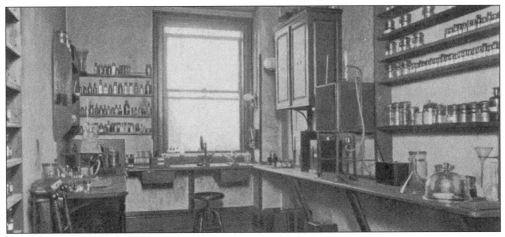

Although the Hoagland Laboratory was completed on October 1, 1888, its formal opening did not take place until December 15. The main speaker on this occasion was Dr. H. Newell Martin, professor of biology at Johns Hopkins University. His talk was entitled "Some Thoughts on Laboratories." He compared the public laboratories in Europe with those in this country that were being built and endowed "by private generosity." He stated that through "private endowments—trusts as they are for the public welfare—American science promises to attain a variety and independence of thought such as no national science has ever had in the past." Seen here is a private laboratory for research work.

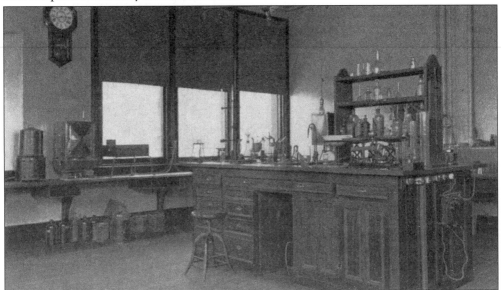

The first lecture in the Hoagland Laboratory was given to medical students on September 28, 1888, by Joseph H. Raymond, a professor of physiology and graduate of the Class of 1868. Raymond later served as secretary of the faculty for 30 years. The laboratory course in practical bacteriology began on October 20, 1888, and continued until May 1. There were no set hours. The students came to the third floor and worked at their convenience, receiving cultures, materials, and instructions as needed from George Kemp, the instructor in bacteriology. First on the list of students was Dr. Joseph H. Raymond, mentioned above. Another student was Dr. Z. Taylor Emery, who soon became the City of Brooklyn's commissioner of health. This laboratory worktable was available within the Department of Bacteriology.

After Dr. Z. Taylor Emery became Brooklyn's commissioner of health in 1894, he immediately created the Bureau of Pathology, Bacteriology, and Disinfection on the third floor of the Hoagland Laboratory under Dr. Ezra Wilson, seen here. Wilson was the head Department of Bacteriology. He first began providing physicians with units for making throat cultures to diagnose diphtheria. He then began preparing diphtheria antitoxin for therapeutic use. At the same time, the staff issued circulars to physicians and the public on the proper methods of disinfection. In 1894, the staff turned its attention to the bacteriology of milk, issuing simple directions for making milk safe for babies by home pasteurization. When Brooklyn became part of the greater city of New York in 1898, the Brooklyn Board of Health was abolished. That year, the Bureau of Pathology, Bacteriology, and Disinfection also ceased to exist. The death of Ezra Wilson in 1905 left the Department of Bacteriology in the hands Benjamin White. Although White was a competent biochemist, he felt that his training in bacteriology was not sufficient for this responsibility. He therefore decided that he should have a year of specialized training abroad. After he left for Europe in June, the Department of Bacteriology was closed until his return. In Europe, he studied bacteriology, protozoology, and serology at the Imperial Institute for Infectious Diseases at Berlin. He also studied epidemic meningitis at St. Anna's Kinderspital in Vienna and vaccine therapy at St. Mary's Hospital in London.

Upon his return, White appointed Dr. Oswald T. Avery, pictured here, as associate director. Both White and Avery were interested in the therapeutic and prophylactic use of vaccine and in the bacteriology of post-surgical infections. In 1909, White suffered a severe hemorrhage in the lungs and was sent to the Trudeau Sanitarium at Saranac Lake. During his stay there, he accomplished a great deal of research on the chemistry of the tubercle bacillus. Avery eventually joined him in the research, and the first part of their work was completed in 1911. Avery resigned as associate director of the Department of Bacteriology in 1913 to go to the Rockefeller Institute for Medical Research. There, his brilliant research into the structure and serology of pneumococci made scientific history. White resigned as director in 1911 and became assistant director of the Bacteriological Laboratories of the New York City Department of Health. He was in charge of the antitoxin laboratories at Otisville, New York. He later became director of the Biologic Laboratories of the Massachusetts State Department of Health and assistant professor of bacteriology and immunology at Harvard Medical School. After White's departure, no more research was done with the funds of the laboratory. Although it remained under a separate board of trustees, the laboratory was devoted exclusively to the teaching and research needs of the medical school.

William Alanson White, M.D., who later became one of the leading psychiatrists in the country, graduated from the Long Island College Hospital in 1891. The following year, he became a staff member of the Binghamton State Hospital, where he remained for 11 years. During this period, he also spent some time in New York City at the newly founded Pathological Institute of the New York State Hospitals (later the Psychiatric Institute). In 1903, at the age of 33, he was appointed by Pres. Theodore Roosevelt to be superintendent of the Government Hospital for the Insane (later St. Elizabeth's Hospital) in Washington, D.C. During the next 34 years at this post, Dr. White won international distinction for his writings on psychiatry and mental hygiene. In 1907, he published his *Outlines of Psychiatry,* which became a standard text in the field and went through 14 revised editions. He was appointed professor of Psychiatry at George Washington School of Medicine in 1904. For many years, he held a similar chair at Georgetown University School of Medicine. From 1904 until his death, he taught psychiatry in the U.S. Army and Navy Medical School, giving clinical courses at St. Elizabeth's Hospital for the Medical Corps of these services. He is credited with having introduced psychiatry into the military service. At the close of World War I, the U.S. Veterans Administration was confronted with thousands of soldiers in need of neuropsychiatric examinations, classification, and treatment. In response, White organized St. Elizabeth's as a postgraduate school and mobilized his staff to train students. In 1937, White died of pneumonia in Washington in his 68th year. Two years before, he had returned to his alma mater as a guest of honor for the annual Alumni Association dinner.

The Polhemus Memorial Building was completed and occupied in December 1897. This building was erected by Mrs. Caroline H. Polhemus in memory of her late husband, Henry Ditmas Polhemus, seen here. Polhemus had been a regent of the Long Island College Hospital since 1872 and was one of its most zealous friends. He died in 1895.

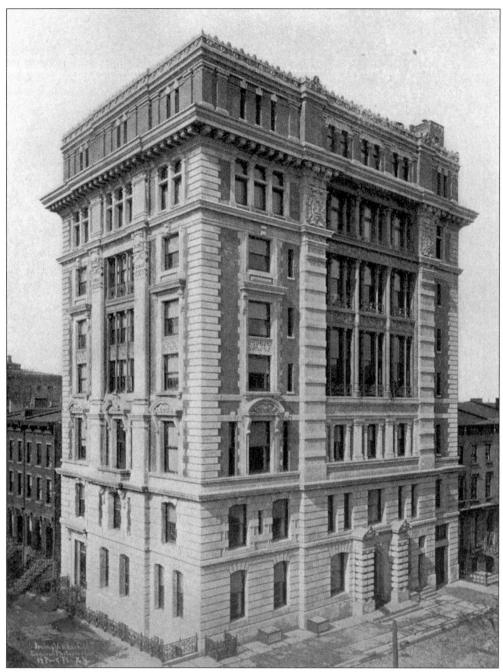

The new eight-story Polhemus Memorial Building was erected on the southwest corner of Henry and Amity Streets. The first two floors were devoted to the hospital dispensary; the third floor to offices of administration for the college division and student locker rooms; the fourth, fifth, and sixth floors to two large lecture halls and several small class and preparation rooms; the seventh floor to chemistry laboratories; and the eighth floor to dissecting and other rooms for the Department of Anatomy.

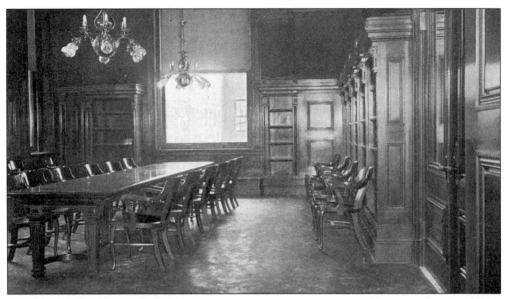

The Polhemus Memorial Building was formally opened on January 5, 1898. The opening lecture was delivered by Dr. Alexander J.C. Skene, Class of 1863, who was then president of the college division. The library is shown here.

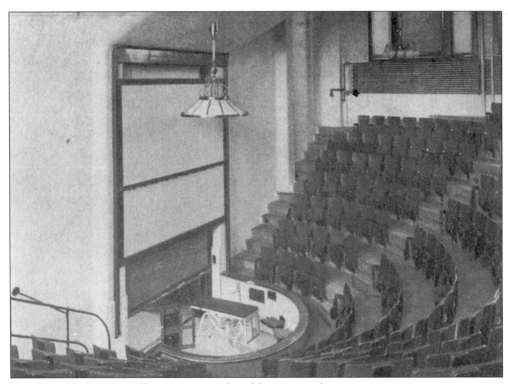

The clinical hall in the Polhemus Memorial Building is seen here.

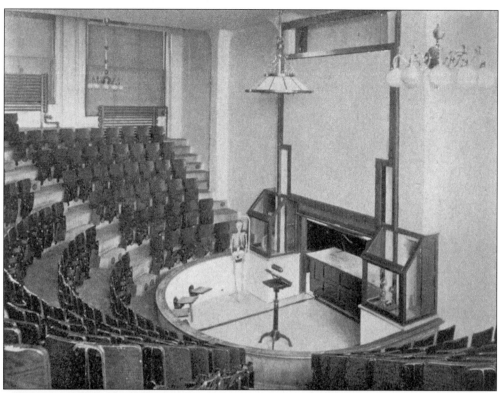

This lecture hall can be found in the Polhemus Memorial Building.

Students' lockers were located on the third floor of the Polhemus Memorial Building.

Seen here is the nose and throat treatment room in Polhemus Memorial Clinic. In the spring of 1898, the war department asked the Long Island College Hospital to help care for sick and wounded soldiers of the Spanish American War. On the morning of Sunday, July 17, the first detachment of invalid troops arrived in Brooklyn on the U.S. Hospital Ship *Olivette* from Cuba. A line of ambulances, carriages, and patrol wagons met the ship and removed 120 men to different hospitals. The Long Island College Hospital received 50 of these cases.

Between July 1898 and March 12, 1899, 421 men were admitted to the hospital at the request of the war department. The total number of deaths was 12. The U.S. Army Hospital on Governor's Island also turned over many of its serious operative cases to the Long Island College Hospital. The U.S. Marine Hospital sent cases to be diagnosed by the aid of the x-ray machine that was available in the Polhemus Memorial Building. The dispensary waiting room in the Polhemus Memorial Building can be seen here.

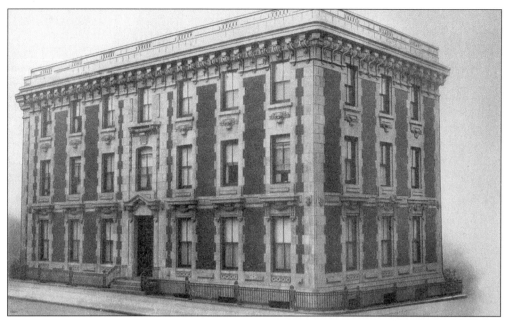

In 1899, Henry W. Maxwell erected a building on the corner of Henry and Amity Streets to be used as a nurses' home. This building (shown above) was named in honor of Dr. William H. Dudley. Shortly after the death of Henry Maxwell, his brother, J. Roger Maxwell, who was a regent of Long Island College Hospital, announced that he would erect an entirely new hospital on the site of the old one as a memorial to his brother. The Maxwell Memorial was one of the most complete hospitals in the country and was able to accommodate 400 patients.

Dr. Frederick Tilney, a leader in American medicine, did much to shape the present-day form of neurology. He graduated from Long Island College Hospital in 1903 as valedictorian. The following year, he studied at the University of Berlin under the great neurologist Dr. Herman Oppenheim. Upon his return, he entered private practice in Brooklyn and became a lecturer in embryology and an instructor in neurology at the college. At the same time, he pursued special studies in anatomy, embryology, and nervous diseases under a fellowship founded by Dr. Joshua M. Van Cott. In 1912, Tilney was awarded a Ph.D. degree in embryology by Columbia University. Two years later, he was appointed associate professor of neurology at the college of physicians and surgeons. The following year, he was appointed as a professor of neurology, remaining in this post until his death. In 1919, Tilney was appointed to a staff position at the Neurological Institute of New York. He later served as director from 1935 to 1938, after the institute had merged with Columbia University and was moved to a new building at the Columbia Presbyterian Medical Center. Tilney's work was chiefly in the anatomy and morphology of the nervous system and the development of the brain. His investigations were based on the firm belief that the form and functions of the nervous system must be considered together. He was prolific writer. His first book (with Dr. Henry A. Riley) was *The Form and Functions of the Central Nervous System*, which became a standard text in the field. In 1928, he published his monumental two-volume comparative study of the brain entitled *The Brain from Ape to Man*. His more popular study of the brain, *The Master of Destiny* (1930) was chosen for distribution by the Scientific Book Club.

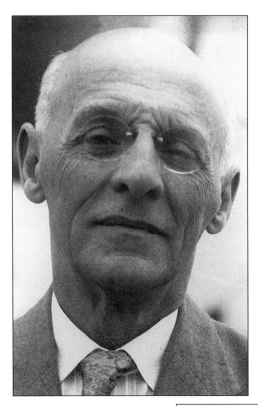

Abraham Flexner was commissioned by the Carnegie Foundation to make a full-scale investigation of American medical schools. The published results of his two-year inspection revealed such serious deficiencies in many of the schools that about half were eventually forced to close. Those that survived, such as the Long Island College Hospital, were found deficient in varying degrees. The Long Island College Hospital was criticized because of the lack of full-time teachers in laboratory subjects and because of inadequate laboratory facilities. As a result, the Council on Medical Education of the American Medical Association gave the college a Class B rating. The next four years were devoted to remedying the shortcomings of the college.

In 1911, three teachers were placed on a full-time salaried basis. In the following year, five more were made full time. A laboratory course in physiology was inaugurated in 1912, and one in pharmacology in 1913. At the same time, the number of laboratory hours in other courses was increased and work was begun on the Pathological Museum. Finally, in the fall of 1914, a year of premedical college work was required for admission. In recognition of these and other improvements, the Council on Medical Education of the American Medical Association raised the rating of the Long Island College Hospital from Class B to Class A on June 21, 1914.

BROOKLYN: *Population*, 1,543,630.

(2) LONG ISLAND COLLEGE HOSPITAL. Organized 1858. An independent institution.

Entrance requirement: The Regents' Medical Student Certificate.

Attendance: 360, 89 per cent from New York state.

Teaching staff: 94, 9 being professors, 85 of other grade. There is no full-time instructor belonging to the school.

Resources available for maintenance: Fees, amounting to $61,398. Practically this amount is supplemented by advantageous arrangements to be described below in connection with laboratory and clinical facilities.

Laboratory facilities: The Hoagland Laboratory (endowment $131,000), independent of but affiliated with this school, sets aside a suite of rooms, in which pathology, bacteriology, and histology are taught to medical students. The college is thus partly relieved of the expense involved in the equipment and teaching of these branches. The opportunities provided are of routine character. The research work of the laboratory and its teaching are entirely distinct.

The college itself contains a good and well kept dissecting-room, in which drawing and modeling are employed, and two good, though ordinary, chemical laboratories.

There is no library, no museum, no physiological or pharmacological laboratory, though a demonstration course in physiology is offered. Freed from the necessity of providing certain laboratories, fees might have been used to provide others; instead of that, the surplus is annually divided among the faculty. What gifts have not provided, the college goes on lacking.

Clinical facilities: The school adjoins, and is legally one with, the Long Island College Hospital, with 200 beds usable in teaching. The hospital, though new, is not designed to serve modern ideas in medical teaching. It lacks adequate laboratories; specimens must be carried by students to the college building for examination.

For dispensary purposes, the college gets the use of the Polhemus Clinic, built at a cost of $500,000, having a productive endowment of $400,000.

The entire plant—school and clinic—is admirably kept.

Shown is *Robert L. Dickinson's self portrait at the age of 70.* In 1919, Dr. Robert Latous Dickinson was appointed clinical professor of obstetrics and gynecology at the college; he had served as assistant professor since 1899. Dickinson received his M.D. degree from the Long Island College Hospital in 1882. He studied in Germany and Switzerland before returning to Brooklyn to become chief of gynecology and obstetrics at the Brooklyn and Methodist Hospitals. During WWI, he was assistant chief of the medical section of the National Defense Council and medical adviser on the general staff. He served in turn as president of the American Gynecological Society, as chairman of the obstetrical section of the American Medical Association, and as honorary chairman of the Committee on Maternal Health. Dickinson's first medical article was published when he was 26 years old.

By 1919, Dickinson had written over 100 papers, chiefly on clinical topics. Many of his early advances in clinical gynecology and obstetrics have been standard practice for almost half a century and have almost been forgotten in light of his later activities. Having decided that no surgeon should continue to operate after reaching the age of 60, he withdrew from active practice in 1920. He embarked on a second career, devoting himself to marriage counseling and studies in human fertility and sterility. He became the undisputed medical leader in these fields during the last 30 years of his life. This Alumni Medallion was replicated from an original design of his.

Dr. Robert Latous Dickinson is seen here in his studio. This period of Dickinson's life yielded another 50 publications, including several books. The subjects ranged widely and included the following titles: *The Control of Conception* (1931), *A Thousand Marriages* (1932), and *The Atlas of Human Sex Anatomy* (1933). The first physician of prominence to advocate voluntary birth control, Dickinson prepared the first modern medical pamphlet on the subject, which was sent to physicians through the mail. He initiated one of the earliest surveys on sterilization of men and women and was a leader in birth control organizations, such as the Sanger Bureau and the Planned Parenthood Federation.

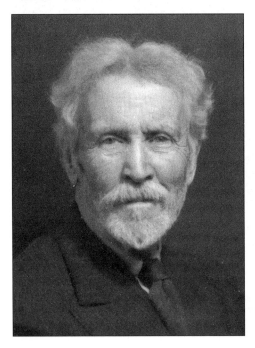

In addition to his attainments as clinician, teacher, and author, Dickinson was an artist and sculptor of recognized ability. Most of his books, including the *New York Walk Book*, published in 1921, were self-illustrated. His 100 life-size teaching models of stages of labor and pregnancy were developed in his studio-museum at the New York Academy of Medicine in cooperation with sculptor Abram Belskie. They are now in the possession of the Cleveland Health Museum. The largest group among these, called the *Birth Series*, was shown under the auspices of the Maternity Center Association at the New York World's Fair in 1939. In the early 1940s, Dickinson was commissioned to design for his alma mater an alumni achievement medallion to honor graduates of the college who made notable contributions to American medicine. At the 86th commencement ceremony on September 28, 1944, Dickinson was the first alumnus to be awarded this medallion.

Professor Warren appears with his section in medicine, 1923.

Dr. Jean Redman Oliver became chairman of the Department of Pathology in 1929. During his 25-year tenure, he became world famous for his work on the kidney. His most significant accomplishment was the microdissection of the individual nephrons to demonstrate their morphology, pathology, and metabolism. In 1954, he was named the first distinguished professor of the State University of New York.

In 1921, the college offered a series of postgraduate courses for practicing doctors in the community. The following year, in celebration of its centenary, the Medical Society of the County of Kings offered a "Practical Lecture Series" for physicians. Following the success of these separate endeavors, the college and the medical society became affiliated for the purpose of establishing a program of postgraduate medical education in Brooklyn. Committees from the two organizations met and formed the Joint Committee on Postgraduate Education. Postgraduate teaching began on April 16, 1923, and continues to this day.

In 1923, the college became affiliated with the department of Public Welfare of the City of New York. This meant that medical students were sent for clinical instruction under faculty members of the college to Kings County, Greenpoint, and Kingston Avenue Hospitals. Kings County is seen below.

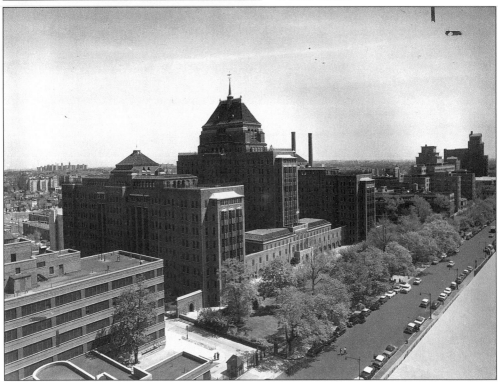

Three

INDEPENDENCE

University of the State of New York

Absolute charter of

Long Island College of Medicine

This instrument witnesseth. That the Regents of the University of the State of New York

Being satisfied that the required conditions have been met, have granted to Long Island College of Medicine, provisionally

incorporated on June 19, 1930, this absolute charter to replace its provisional charter, with power to confer the degree of

Doctor of Medicine (M.D.), in conformity with the rules of the Regents of the University and the regulations of the

Commissioner of Education for the registration of institutions of higher education, and have continued the said

corporation with all its powers, privileges and duties.

Granted March 19, 1931 by the Regents
of the University of the State of New York,
executed under their seal and recorded in their
office. Number 4007

In 1929, the faculty of the college decided that the college and the hospital should be reorganized as separate institutions, each under its own governing board. By this time, the college had expanded its affiliations for clinical teaching to include a number of other hospitals in Brooklyn. The faculty felt that it was no longer advantageous for it to be governed by the board of a single hospital. Early in 1930, the board of regents of the Long Island College Hospital voted to approve the separation, with the hospital retaining the old name and the college becoming the Long Island College of Medicine. The new board of trustees for the college had 25 members. About half of them had been regents of the Long Island College Hospital. The executive officers, teaching staff, and student body remained as they were, in unbroken continuity.

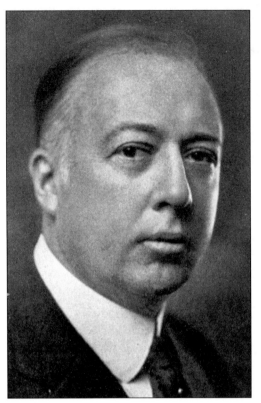

A new building just east of the Hoagland Laboratory was formally opened on March 5, 1931. This building, originally called the Science Laboratory, was donated by Dr. John Osborn Polak, professor of obstetrics and gynecology. Title to the building was vested in the hospital, but Polak specified that the major portion of it was for the use of the college. Polak, who was a graduate of the Class of 1891, died on June 29, 1931. His connection with the college had begun the year after his graduation, when he became an instructor in histology and obstetrics. He continued in this function until his death, by which time he had served as professor of obstetrics and gynecology for 20 years. On March 26, 1931, a few months before his death, he was elected president of the board of regents. After his death, the name of the Science Laboratory Building was changed to the John Osborn Polak Memorial Laboratory.

John Lavalle painted this portrait of Dr. Frank L. Babbott. Effective July 1, 1931, Dr. James C. Egbert resigned as president of the college and the board of trustees appointed Dr. Babbot to this post. Babbott took office on July 1, 1931, and was formally installed January 14, 1932, at ceremonies in the Brooklyn Academy of Music. During the decade of Babbott's administration, the basic science departments were further strengthened and full-time leadership was introduced in the Departments of Preventive Medicine and Community Health, Psychiatry, and Internal Medicine. Research activities were encouraged by providing equipment for the laboratories, by the recruitment of outstanding investigators, and by strengthening and expanding the hospital's teaching affiliations. The college's first endowment was obtained through Babbott, whose father left a bequest of $1,700,000 in his will "for medical education and research."

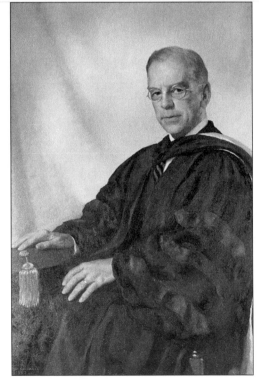

The famous Viennese psychiatrist Dr. Alfred Adler, who coined the phrase "inferiority complex," joined the faculty in 1932 as visiting professor of medical psychology. Adler conducted a course in applied medical psychology for second year students and gave a series of talks to the medical profession under the auspices of the Joint Committee on Postgraduate education. He also organized the Adler Medical Psychology Clinic at 364 Henry Street as an affiliate of the college.

Adler had a close association with Sigmund Freud. However, when Freud would not accept Adler's theory of individual psychology, their professional association disbanded. This controversy raged for a quarter century, dividing psychiatrists into two groups: those who believed with Freud that the problems of the mind grew out of basic instincts and those who accepted Adler's theory that social drives and needs were the key to human behavior. Adler died in 1937 while on leave from the faculty for a lecture tour of England, Scotland, and the Netherlands.

In 1933, Cornelia E. and Jennie A. Donnellon donated their residence at 116 Pacific Street as a recreation center for students. The basement of the building was converted into a cafeteria for students and faculty. The cafeteria was later enlarged and given the name the Open Gate.

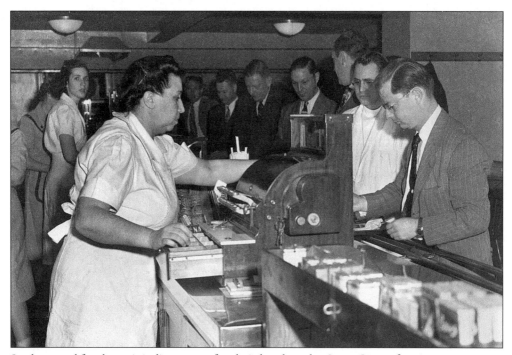

Students and faculty wait in line to pay for their lunch at the Open Gate cafeteria.

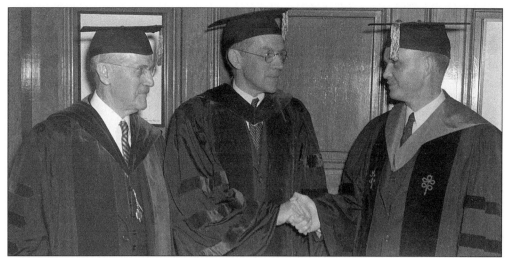

On September 26, 1941, at the insistence of his physician, Dr. Frank L. Babbott resigned as president of the college and Dr. Jean A. Curran, who had been dean since 1937, was elected president. Former presidents Dr. James C. Egbert (left) and Dr. Babbott (center) congratulate Curran at his installation as the new president on November 19, 1941.

Curran served in the dual capacity of dean and president until 1948, when he resigned as dean because of the pressure of other duties. He remained president until 1950, when this position was abolished because of the merger with the State University of New York. At that time, he became dean again.

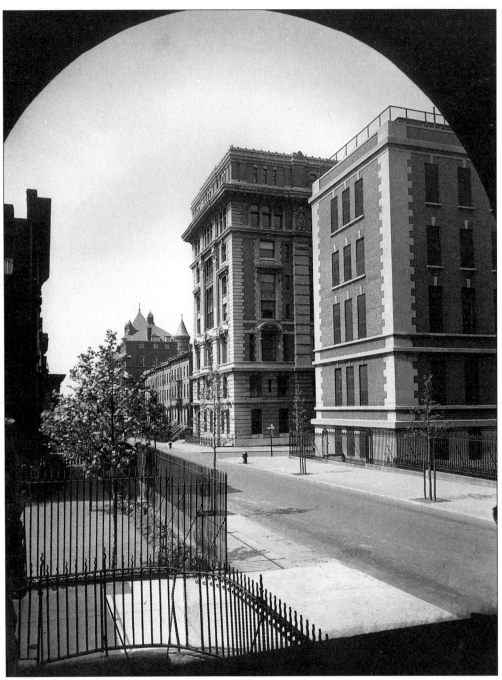

This well-known photograph looks through the arched portico of the Hoagland Laboratory toward the Polhemus Memorial Building and the Maxwell Memorial. The building with the turrets in the background is St. Peter's Hospital, which was established in 1864 and stands on Henry Street between Warren and Congress Streets.

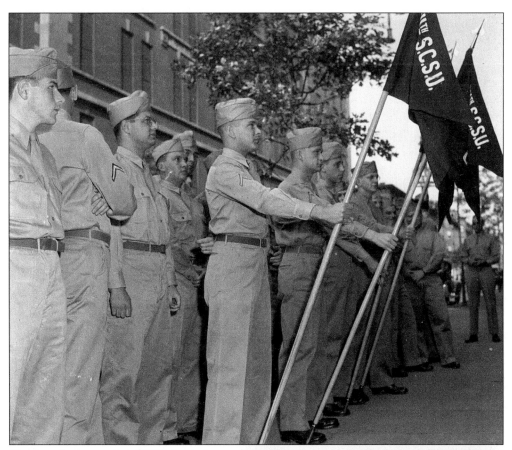

The American entry into WWII drew the college into the war effort. Its major objective was to turn out as many efficient doctors as possible in the shortest period of time. The size of the entering class was increased, and a schedule of year-round teaching was instituted so that students could complete the course in three years instead of four.

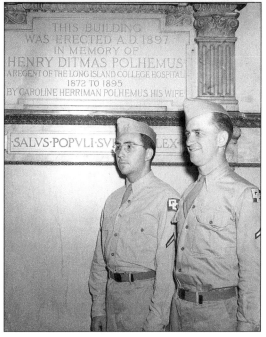

Alexander Garcia (1943), on the left, and William P. Riley (1944) were the presidents of the two upper classes. They are pictured in their uniforms in the lobby of the Polhemus Memorial Building. In June 1941, the war department asked the college to cooperate in establishing the 79th General Hospital, which was to operate as a 1,000-bed military hospital unit with 55 medical officers, 100 nurses, and 500 enlisted men. The college was asked to recruit 35 to 40 members of its teaching staff for the hospital unit.

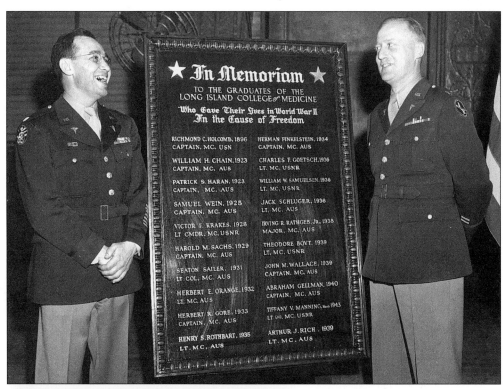

★ In Memoriam ★
TO THE GRADUATES OF THE LONG ISLAND COLLEGE of MEDICINE
Who Gave Their Lives in World War II In the Cause of Freedom

RICHMOND C. HOLCOMB, 1896 CAPTAIN, MC, USN	HERMAN FINKELSTEIN, 1934 CAPTAIN, MC, AUS
WILLIAM H. CHAIN, 1923 CAPTAIN, MC, AUS	CHARLES F. GOETSCH, 1936 LT, MC, USNR
PATRICK S. HARAN, 1923 CAPTAIN, MC, AUS	WILLIAM W. SAMUELSEN, 1936 LT, MC, USNR
SAMUEL WEIN, 1925 CAPTAIN, MC, AUS	JACK SCHLUGER, 1936 LT, MC, AUS
VICTOR F. KRAKES, 1928 LT CMDR, MC, USNR	IRVING R. RATHGEB, Jr., 1938 MAJOR, MC, AUS
HAROLD M. SACHS, 1929 CAPTAIN, MC, AUS	THEODORE BOYT, 1939 LT, MC, USNR
SEATON SAILER, 1931 LT COL, MC, AUS	JOHN M. WALLACE, 1939 CAPTAIN, MC, AUS
HERBERT E. ORANGE, 1932 LT, MC, AUS	ABRAHAM GELLMAN, 1940 CAPTAIN, MC, AUS
HERBERT R. GORE, 1933 CAPTAIN, MC, AUS	TIFFANY V. MANNING, March 1943 LT (jg), MC, USNR
HENRY S. ROTHBART, 1935 LT, MC, AUS	ARTHUR J. RICH, 1939 LT, MC, AUS

This memorial plaque was unveiled in honor of the graduates of the Long Island College of Medicine, "Who gave their lives in World War II in the Cause of Freedom."

Physically qualified students were enrolled in the U.S. Army and Navy Reserve components, but remained at their studies. Army officers in charge of indoctrination and training had their headquarters in Donnellon House.

United States Navy

Bureau of Medicine and Surgery

To

The Dean and Faculty of
Long Island College of Medicine

Certificate of Commendation

The Surgeon General, on behalf of the Medical Department of the Navy, commends you for your splendid cooperation and outstanding contribution to the education of Navy V-12 medical students for appointment in the Medical Corps of the Navy. You have rendered a distinguished service to your country during the period of World War II.

Washington, October 27, 1945

Ross T McIntire

ROSS T McINTIRE
Vice Admiral (M C), Surgeon General
United States Navy

This certificate of commendation was issued to the dean and faculty of the Long Island College of Medicine from the surgeon general for "cooperation and outstanding contribution" to the education of medical students for appointment in the Medical Corps of the U.S. Navy.

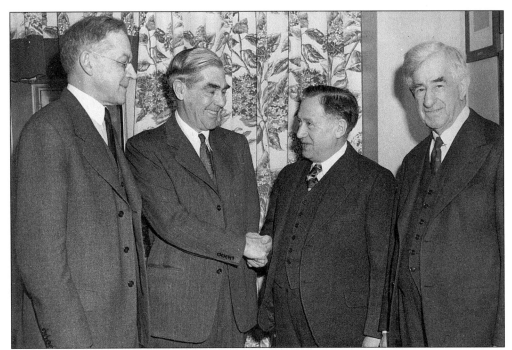

After more than three decades of training medical students, professor of bacteriology Dr. Wade Oliver (third from right), left for the Rockefeller Foundation, where he became an associate director of medical sciences. Judge Nathan Sweedler (second from right) gave a testimonial luncheon in his honor at the Lawyer's Club at 115 Broadway on February 5, 1948. Looking on are Dr. Frank L. Babbott (left), the chairman of the board of trustees, and Edward Lazansky (right), a member of the board.

The State University of New York, established by the state legislature in 1948, began a study of medical school facilities in New York State with a view to carrying out its mandate of providing an expanded program of medical education and research.

A faculty committee was appointed to investigate the desirability of merging the college with the state university. After visiting a number of state educational institutions in New York and elsewhere, the committee submitted a favorable report. The board of trustees of the college and the board of managers of the alumni association then approved the plan and submitted a proposal to the New York State University Board of Trustees.

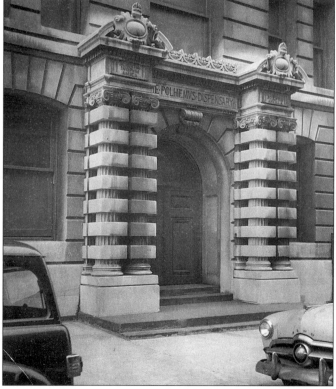

After careful study and consideration of the various proposals submitted to them, the university trustees decided that the Long island College of Medicine offered the best possibilities for establishment of a medical center in the New York metropolitan area.

The Hoagland Library was relocated to the third floor sometime between 1896 and 1900. The Flexner report (page 44) had called attention to inadequate library facilities in the medical school. At the request of the college, the Hoagland trustees decided to allow students access to the library under direction of the librarian in 1914.

The library was enlarged by the addition of another room in 1931 and 1932, providing space for another 3,000 volumes. Adequate library facilities would not be found until the library relocated to its new facility in the Basic Sciences Building on Clarkson Avenue after the merge with the State University of New York.

Four

A NEW CAMPUS
AND SUNY

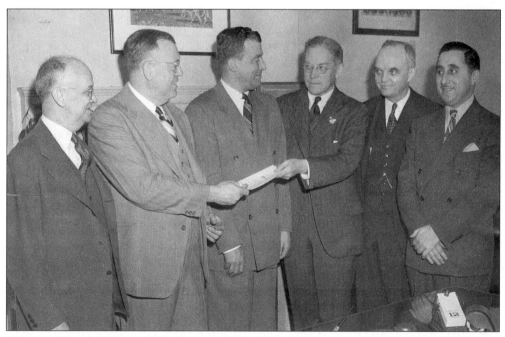

The Long Island College of Medicine took title to a six-acre tract of land opposite the Kings County Hospital on Clarkson Avenue for its projected new campus. Seen here, from left to right, are Harold C. Parsons, managing agent for the former owners; Atty. John H. Livingston; Dr. Frank L. Babbott, chairman of the board of trustees of the medical school; and Dr. Jean A. Curran, college president. All but two small parcels of the three-block area were conveyed to the college for $287,500.

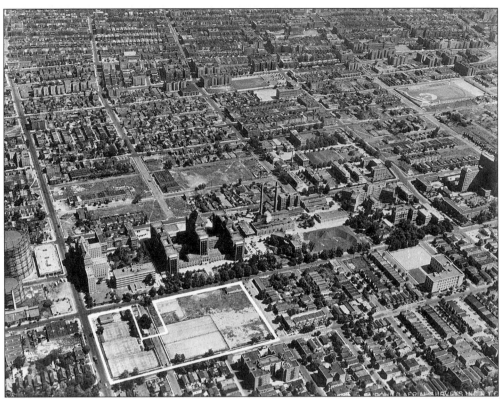

This aerial view shows the new campus of the Long Island College of Medicine. The medical school's property is outlined in white. Shown in the background, from left to right, are the Kings County Hospital, the Kingston Avenue Hospital, and the Brooklyn State Hospital.

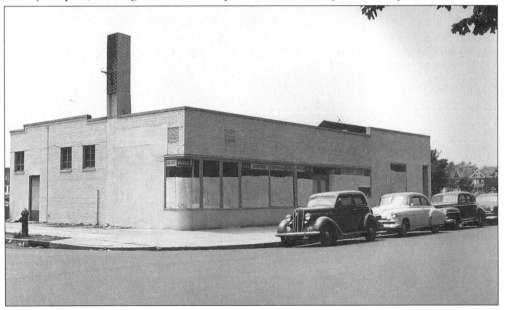

This building, formerly a luncheonette, housed the first offices of the medical school at its new site.

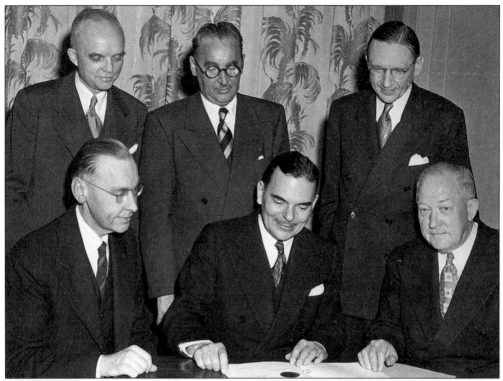

Signatory to the Articles of Merger between the State University of New York and the Long Island College of Medicine on April 5, 1950 were, from left to right, as follows: (seated) Lawson Stone, chairman of the Long Island College of Medicine Board of Trustees; Gov. Thomas E. Dewey; and Dr. Oliver C. Carmichael, chairman of the State University of New York Board of Trustees; (standing) Dr. Jean A. Curran, president of the Long Island College of Medicine; Atty. Gen. Nathaniel L. Goldstein; and Carl Leff, secretary to the Long Island College of Medicine Board of Trustees.

Dr. Duncan W. Clark, dean (at left), and Dr. Jean A. Curran, the president of the College of Medicine at the time of the merger, make plans to accommodate the enlarged faculty and student body.

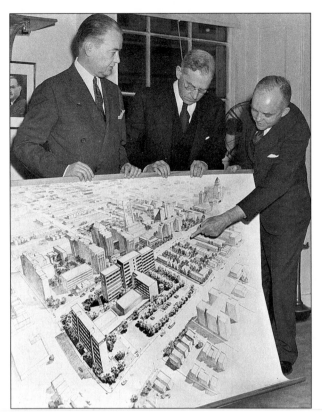

Dr. Jean A. Curran (right) and Dr. Frank Babbott (center) explain plans for the development of the Long Island College of Medicine to the president of the Brooklyn Borough, John Cashmore.

This billboard on the site of the new campus of the medical school solicits contributions from the public to the Long Island College of Medicine at the Brooklyn Medical Center.

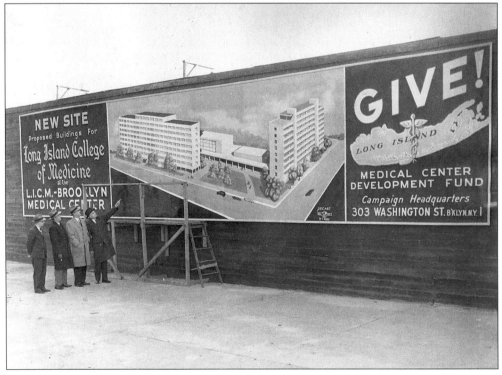

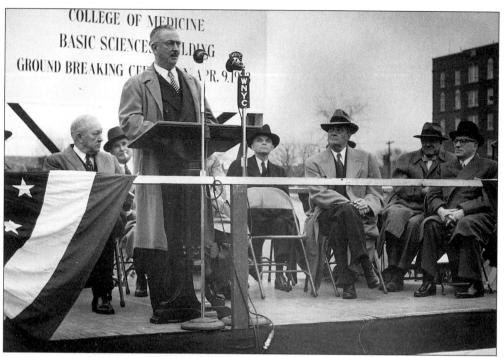

Lt. Gov. Frank C. Moore addresses the spectators at groundbreaking ceremonies for the new Basic Sciences Building of the State University of New York College of Medicine on April 9, 1953. The building would be completed in 1956 and house one of the nation's largest colleges of medicine.

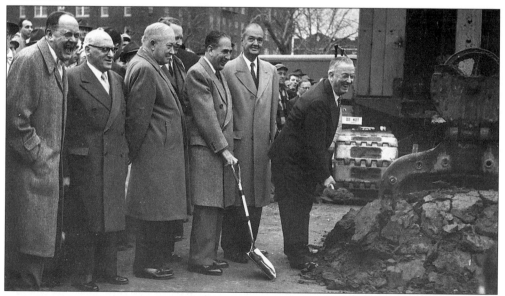

Lieutenant Governor Moore tries his hand at shoveling dirt at the groundbreaking ceremonies. Looking on with amusement, from left to right, are Dr. Carlyle Jacobsen, executive dean for medical education of the State University of New York; Rabbi Sidney S. Tedesche, the Union Temple (Brooklyn); Dr. Oliver C. Carmichael, chairman of the State University of New York Board of Trustees; Mayor Vincent Impelliteri; and Brooklyn Borough President John Cashmore.

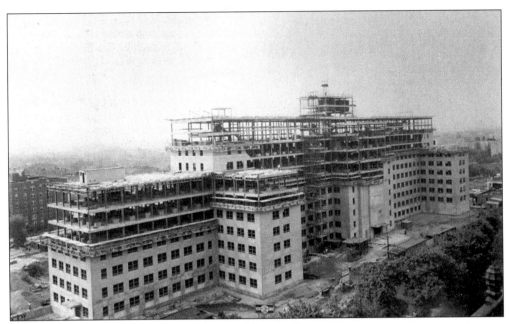

Construction began on the Basic Sciences Building in 1953.

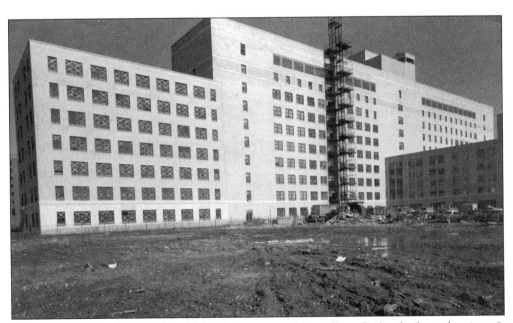

The Basic Sciences Building would be the most modern college facility built at the time. It included modern laboratories, auditoriums, a library, and classrooms. On the top floor would be one of the largest animal laboratories on the eastern seaboard.

Representatives from the city and state governments are seated on the stage to hear President Eisenhower's introductory remarks.

President Eisenhower poses as the cornerstone is unveiled.

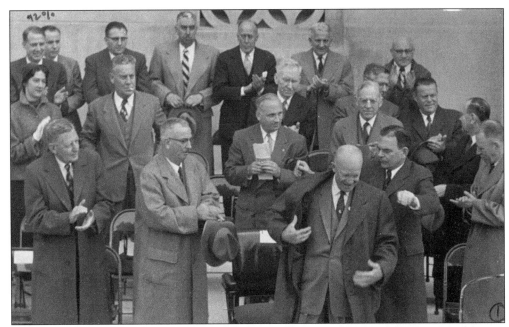

President Eisenhower concludes his address at the cornerstone-laying ceremonies for the Basic Sciences Building on October 21, 1954. Others in the front row include, from left to right, Dr. Howard W. Potter, dean of the College of Medicine, State University of New York; Frank C. Moore, the lieutenant governor of the State of New York; and Thomas E. Dewey, the governor of the State of New York.

Shown is the cornerstone in full view.

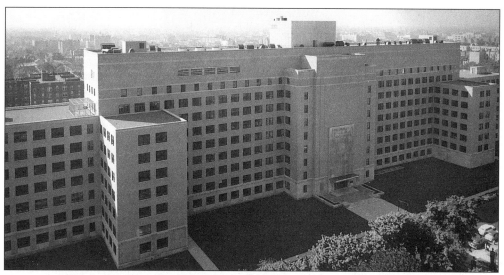

This view of the Basic Sciences Building was taken from the Kings County Hospital across Clarkson Avenue. The Class of 1953 would enter under the Long Island College of Medicine, but complete their studies under the State University of New York College of Medicine at New York City. The Class of 1957 would be the first graduating class to have seen the new building in operation.

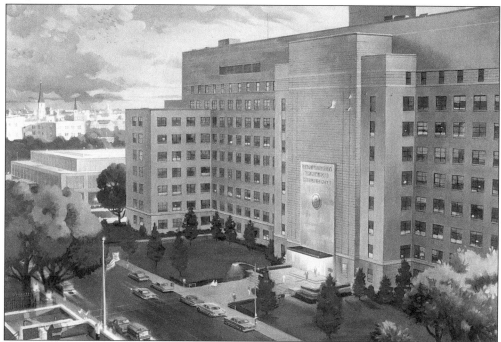

Robert McCall painted this original oil work of the Basic Sciences Building of the State University of New York Downstate Medical Center. E.R. Squibb & Sons Inc., a pharmaceutical firm, commissioned the well-known artist to do the painting as part of a long-range plan to create a collection of original oil paintings representative of the medical schools in America. The painting was presented to the school by Squibb at a luncheon held at the Towers Hotel in Brooklyn on February 25, 1966.

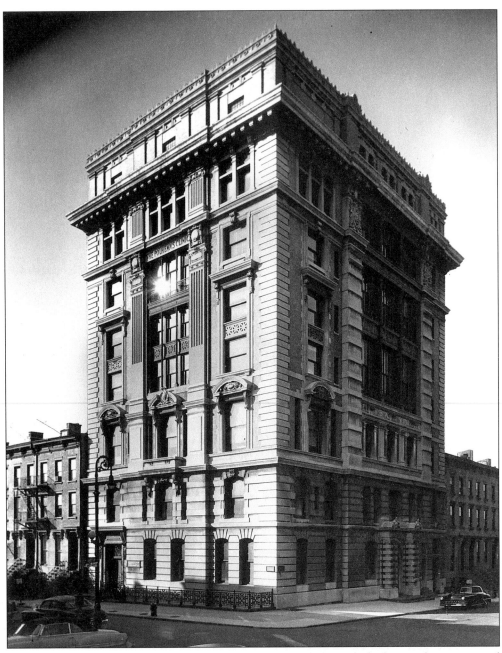

The Polhemus Memorial Building stands majestically in light and shadows, where men and women were taught the medical arts for more than 50 years. Vacating the building allowed the Long Island College Hospital space for its own growth and expansion in the ensuing years.

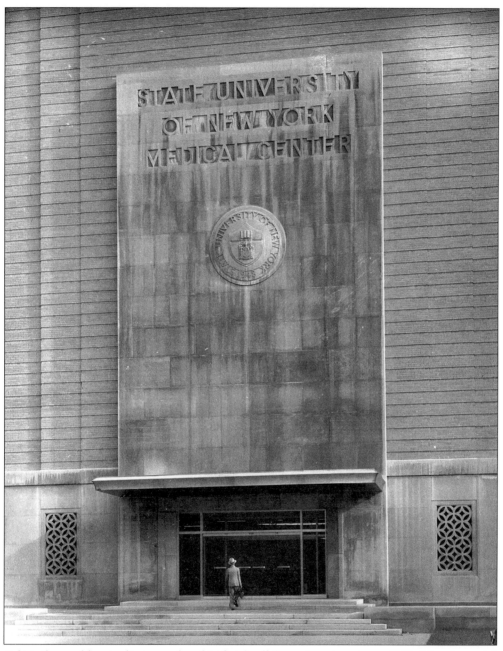

At last, the marble paneling was placed to finish off the main entranceway. Skilled hands moved blocks of finely polished wood to cover the walls of the library. Books, beakers, oscilloscopes, cannulas, and a thousand pieces of equipment made the journey from Henry Street to the "new building."

On June 8, 1957, the ceremonies dedicating the Basic Sciences Building took place before a large gathering. Gov. Averell Harriman gave the dedicatory address. The address by Dr. Jean A. Curran entitled "A Centennial Day of Appreciation and Anticipation" was in behalf of the administration. Dr. Chandler McCuskey Brooks gave the response for the faculty.

Academic processionals would become a familiar sight around the newly constructed campus. Processionals such as this one would be held to inaugurate new presidents as well as to open commencement ceremonies.

Five

RESEARCH AND CAMPUS EXPANSION

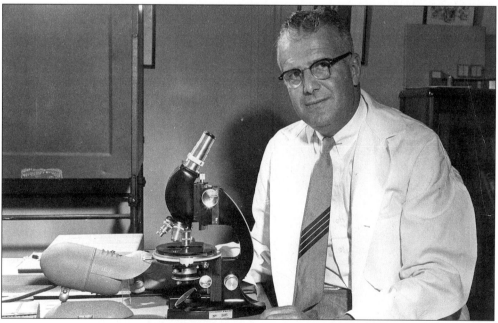

Dr. Louis M. Hellman came from Johns Hopkins and was named chairman of obstetrics and gynecology. He was largely responsible for the introduction of medical sonography to obstetrics and gynecology in the United States. He was also instrumental in associating the Midwifery Program at Kings County Hospital with the Department of Ostetrics and Gynecology. In 1974, the registration of the nurse-midwifery program was changed from the Maternity Center Association to SUNY Downstate Medical Center's College of Health Related Professions. He is most widely known as an editor of *William's Obstetrics*.

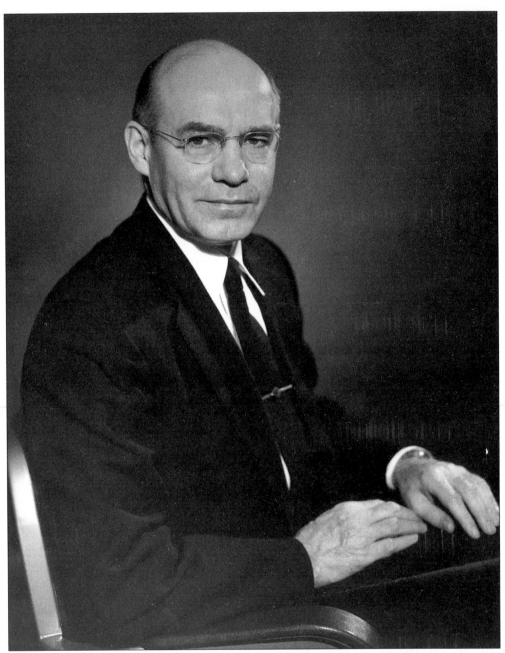

Dr. Chandler McCuskey Brooks came from Johns Hopkins in 1948 to become professor and chairman of the combined Departments of Physiology and Pharmacology. He was one of the first to put a pacemaker in a dog; this early outstanding work contributed significantly to the development of today's human cardiac pacemakers. He was also a forerunner in the field of micro-electrode cardiac physiology, along with Dr. Brian Hoffman and Dr. Mario Vassale. When Dr. Furchgott took over as chair of pharmacology in 1956, Brooks continued to serve as chairman of physiology until 1971. He assumed the added responsibilities of dean of the graduate school in 1968. He also served as acting dean of the medical school and acting president of SUNY Downstate Medical Center from 1969 to 1971.

In 1956, Dr. Robert E. Furchgott became chairman of the new Department of Pharmacology. He was a forerunner in the field of adrenergic receptor research. His work with various stimulating and blocking agents has contributed significantly to the elucidation of their mechanisms and modes of action. These results have added greatly to our understanding of the autonomic nervous system and have led to the development of some important medical therapeutics. This work would eventually lead him to a Nobel Prize in 1998.

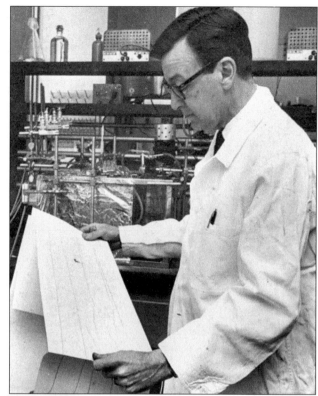

In 1944, the eminent Dr. William Dock was installed as professor and chairman of the Department of Medicine, preceding Dr. Perrin H. Long. He had previously been a professor of pathology at Stanford University Medical School and Cornell University College of Medicine and professor of medicine at the University of Southern California. He was a brilliant diagnostician and outstanding teacher. His clinical expertise was broadly based and practically oriented. He was a leader in non-invasive techniques in evaluating cardiac function with balistocardiography.

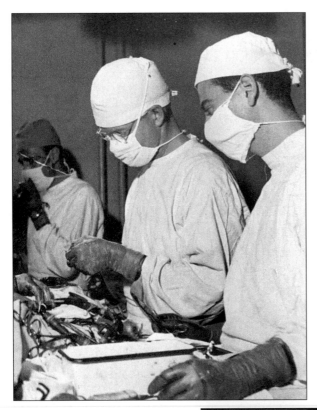

Dr. Clarence Dennis (center) was professor and chairman of the Department of Surgery from 1951 to 1972. He developed the heart-lung machine that revolutionized the field of cardiothoracic surgery. In 1951, Dennis undertook the first open-heart operation with a heart-lung machine ever attempted at the University of Minnesota, just weeks before transferring his research laboratory to SUNY Downstate Medical Center. The procedure was unsuccessful because the patient's heart defect was far more complicated than had been originally diagnosed.

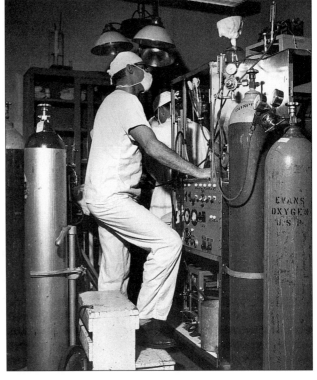

At SUNY Downstate Medical Center, Dennis performed the first successful open-heart operation in New York State on June 30, 1955. It was the second successful such operation ever performed in the United States. The procedure relied on a heart-lung machine that Dennis had built with the assistance of a dedicated team on campus.

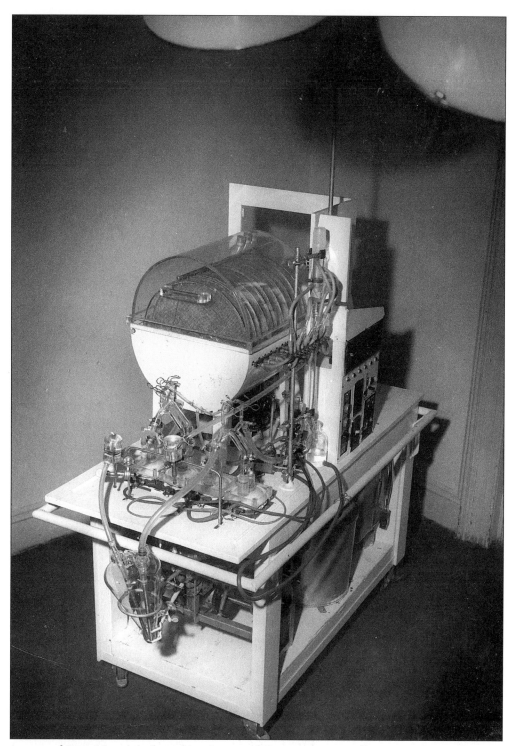

A copy of Dennis's original machine is part of the permanent collection at the Smithsonian Institute in Washington, D.C. A smaller model, for use on pediatric patients, is part of the historical collection of the archives at the SUNY Downstate Medical Center.

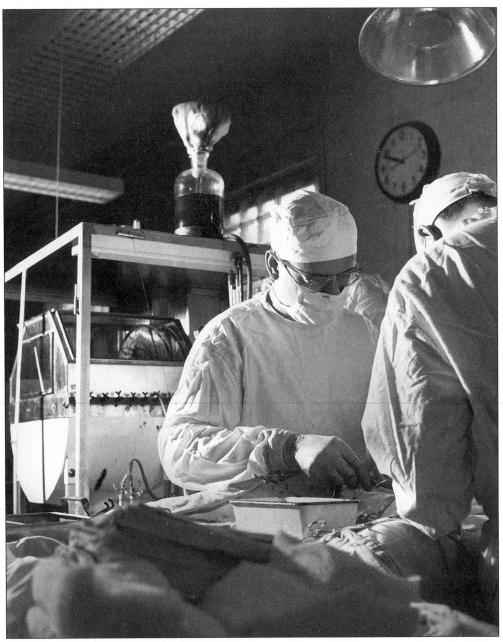

In 1988, Dr. Clarence Dennis and his wife, Mary, announced that they would endow $1 million to surgical research, with an initial gift of $200,000. In May 1996, they presented the institution with a check for an additional $1 million in fulfillment of their endowment pledge.

Dr. Ludwig Eichna graduated from the University of Pennsylvania Medical School in 1932, remaining there for his internship and part of his residency in medicine. He completed his residency at Johns Hopkins and continued on as a fellow in cardiology. After a number of hospital appointments and teaching positions, he eventually became professor of medicine at New York University in 1957. Between 1960 and 1973, he was professor and chairman of the Department of Medicine at SUNY Downstate Medical Center, succeeding the eminent Dr. Perrin Long. In 1975, Eichna entered the freshman class of 1979 as a full-time medical student in order to study first hand the current state of the art of medical education. He attended every lecture, lab, conference, and discussion group; he rotated through the third year clinical clerkships as well as a full schedule of fourth year electives. In addition, he took all the written and oral exams, including the National Boards.

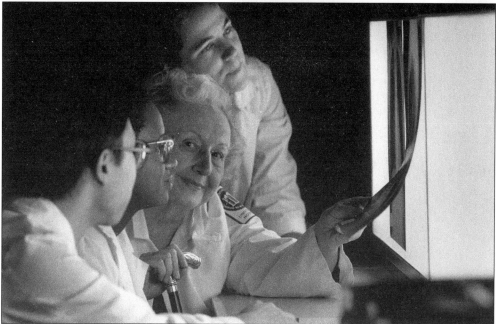

Dr. Lucy Frank Squire joined the faculty in 1970 after teaching at the University of Rochester. In 1964, Squire published the first edition of *Fundamentals of Radiology* with the help of a grant from the Commonwealth Fund and her accumulation of years of teaching materials and three years time. After 35 years and four editions, it remains uncontested as the most valuable book for the radiological instruction of medical students.

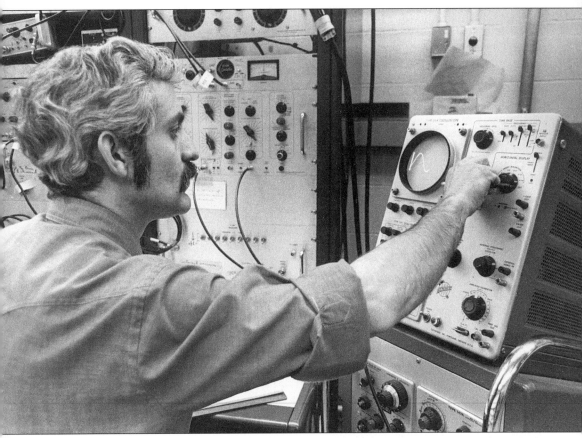

Dr. Raymond V. Damadian is one of the foremost scientists of our time. As the inventor of the diagnostic tool MRI (magnetic resonance imaging), he can lay claim to having changed the practice of medicine. The technology he developed has accelerated the ability of clinicians to detect cancer and other diseases. It has created new pathways for research as well.

Damadian first conceived of the scanner and performed the first experimental proof of its possibility in 1970, while he was a professor of medicine and biophysics at SUNY Downstate Medical Center. He and his students, Larry Minkoff and Michael Goldsmith, built the first MRI scanner at the medical center in 1977.

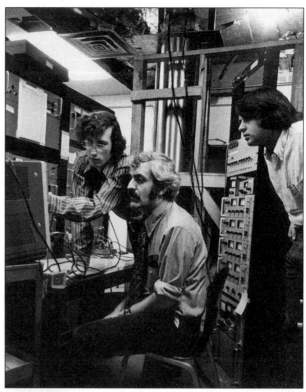

Today, machines based on Damadian's ideas and practical development constitute a rapidly growing, billion-dollar industry. The technology has been refined to produce increasingly clearer images of the internal structures of the body.

Dr. Damadian has been inducted into the National Inventors Hall of Fame by the Patent and Trademark Office, an honor that places him alongside such pioneering figures as Thomas Edison and Alexander Graham Bell. He was awarded the nation's highest honor in technology, the National Medal of Technology, by President Reagan at the White House.

A 1962 graduate of SUNY Downstate Medical Center, Dr. Pascal James Imperato serves as chairman of the Department of Preventive Medicine and Community Health at SUNY Downstate Medical Center, a position he has held since 1978. He was director of the Bureau of Infectious Disease Control and was principal epidemiologist of the New York City Department of Health in 1972. In 1974, he became the first deputy health commissioner and later, the New York City commissioner of health. He was also appointed chairman of the New York City's Health and Hospitals Corporation Board of Directors in 1977.

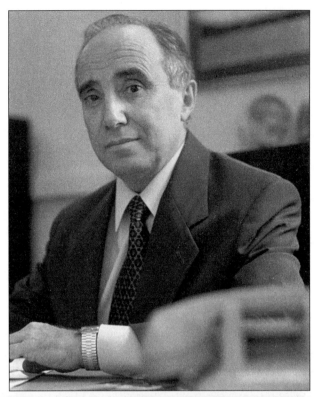

Professor of psychiatry and of neural and behavioral science, Dr. Henri Begleiter's studies of brain function established the first genetic "marker" for alcoholism, paving the way for a provocative new study that is part of the Human Genome Project.

83

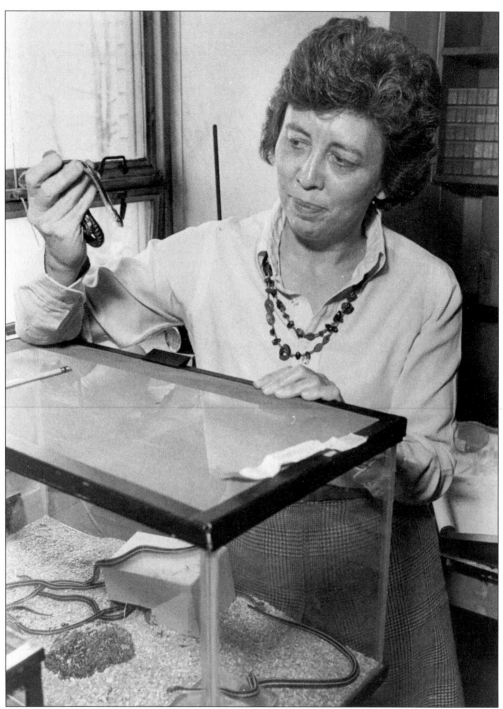

Professor of anatomy and cell biology and professor-director of neural and behavioral science, Dr. Mimi N. Halpern has carefully documented the links from the vomeronasal system to the limbic system to behavior by utilizing garter snakes. Halpern's work has allowed researchers and clinicians to better understand the role that the limbic system plays in integrating many different behaviors, including emotional behaviors and learning.

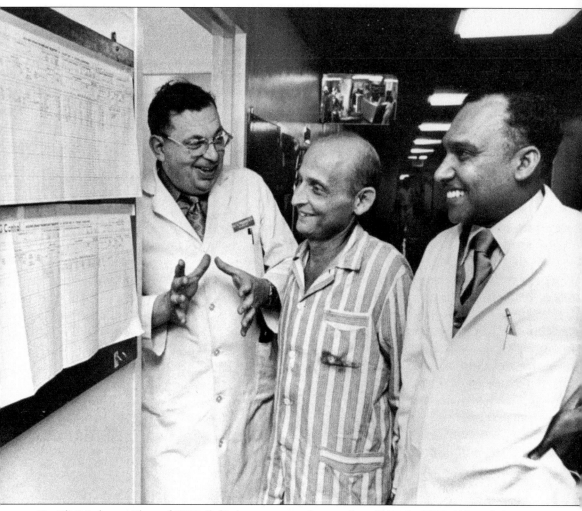

Dr. Eli Friedman, Class of 1951 (left), became a professor of medicine in 1963. Although it was Dr. Scribner of Seattle who first proposed hemodialysis for the treatment of uremia, it was Friedman who advanced this concept and pioneered large-scale dialysis. He was the prime mover in establishing one of the nation's largest and best programs for the medical treatment of renal failure at SUNY Downstate Medical Center. His work made possible the arrival of Dr. Samuel Kountz (right) in 1971.

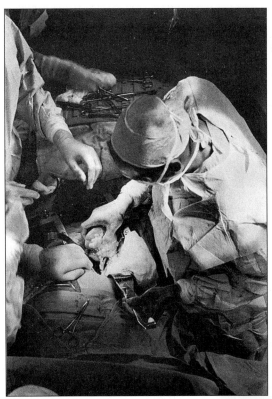

Dr. Samuel Kountz came from Stamford to become professor and chairman of the Department of Surgery. He is credited with having performed more kidney transplant operations than any other surgeon in the United States. He contributed greatly to the development of the procedure and the field of transplant surgery. A disastrous illness ended his brilliant career in 1976. Here, Kountz performs the first kidney transplantation at the SUNY Downstate Medical Center.

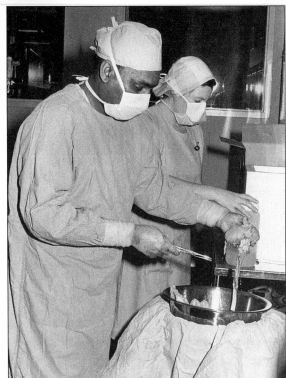

On March 7, 1975, Kountz transplanted a kidney taken from a homicide victim and transplanted it into a 44-year-old police officer of the intelligence division of the New York City Police Department.

Dr. Eli Friedman (center) was one of the chief proponents of home dialysis. He is also credited with having invented the "suitcase dialyzer," shown here.

Friedman and Dr. Dale Distant speak at a transplant symposium at SUNY Downstate Medical Center. Established at SUNY Downstate, the nation's first federally funded dialysis program is attributed to Friedman.

Dr. Herbert Pardes was a recipient of the First Annual Distinguished Alumni Award in 1993. A member of the Class of 1960, he completed a psychiatry residency at Kings County Hospital in 1966. He served as chairman of psychiatry at SUNY Downstate Medical Center from 1972 to 1975 and as director of the National Institute of Mental Health from 1978 to 1984. He has been the Lawrence C. Kolb professor and chairman of the Department of Psychiatry at Columbia University since 1984. He has also been vice president for health sciences and dean of the faculty of medicine at Columbia University, College of Physicians and Surgeons since 1989.

Dr. William Paul, Class of 1960, received the Second Annual Distinguished Alumni Award in 1994. He performed his medical internship and residency at Massachusetts Memorial Hospital in 1962. He has served as chief of the laboratory of immunology at the National Institute of Allergy and Infectious Diseases as well as the National Institutes of Health since 1970. He has been director at the Office of AIDS Research since 1994. He has received the Founder's Prize of the Texas Instruments Foundation, the 3M Life Sciences Award, the Tovi Comet-Wallerstein Prize of Bar-Ilam University, and an honorary D.Sc. from the State University of New York. He is a member of the National Academy of Sciences and the American Academy of Arts and Sciences.

MEDICAL EDUCATION IN BROOKLYN

THE FIRST HUNDRED YEARS

1860 1960

In honoring its 100-year history, the SUNY Downstate Medical Center published a 68-page monograph entitled *Centennial of Medical Education in Brooklyn: the First Hundred Years.* The book chronicles the school's history from its inception until 1960.

On April 30, 1962, an agreement was signed whereby the society's library became part of the Medical Research Library of Brooklyn. At the time, Dr. Leslie H. Tisdall was president of the Medical Society of the County of Kings and Dr. Robert A. Moore was dean and president of SUNY Downstate Medical Center. Those seen here, from left to right, are as follows: (sitting) Dr. Moore, Dr. Tisdall, and Dr. Solomon Schussheim; (standing) Dr. Thomas P. Magill, Wesley Draper, Helen Kovacs, Dr. I. Charles Kaufman, Dr. David Kershner, Dr. George Anderson, and Dr. Irving Drexler.

Arrangements were made with the New York State legislature that called for the two libraries to be housed in a separate wing of the Basic Science Building. A separate entrance to the ground floor section assigned to the Medical Society of the County of Kings was constructed on the Lenox Road approach.

From the main floor of the library, the reference desk area can be seen. When transfer of the materials from the medical society was completed, the two combined libraries made the SUNY Downstate medical research facility one of the most outstanding and largest medical libraries in the nation.

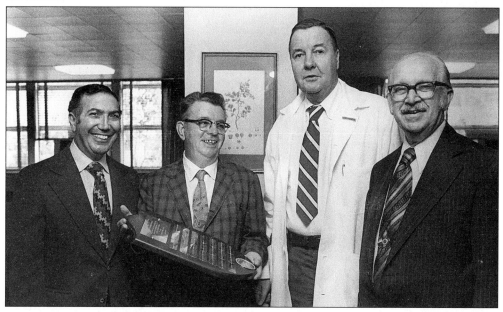

On September 14, 1962, a plaque commemorating the merger of the medical libraries of the Academy of Medicine of Brooklyn and the Downstate Medical Center was presented to President Plimpton (second from right) by Dr. Leslie H. Tisdall (second from left). Tisdall was the immediate past chairman of the Kings County Medical Society Board of Trustees and the president of the society when the contract uniting the two libraries was signed. Also present at the ceremony were Drs. Joseph Fontanetta, president-elect (extreme left) and George Liberman, president of the Kings County Medical Society (extreme right).

91

New Rochelle twins and a Brooklyn couple are being congratulated by Dr. Robert A. Moore, the president of the State University of New York Downstate Medical Center following graduation ceremonies for the Class of 1963. From left to right are Thelma Jones, Carole Jones, Dr. Moore, Barry Weiner, and Phyllis Weiner.

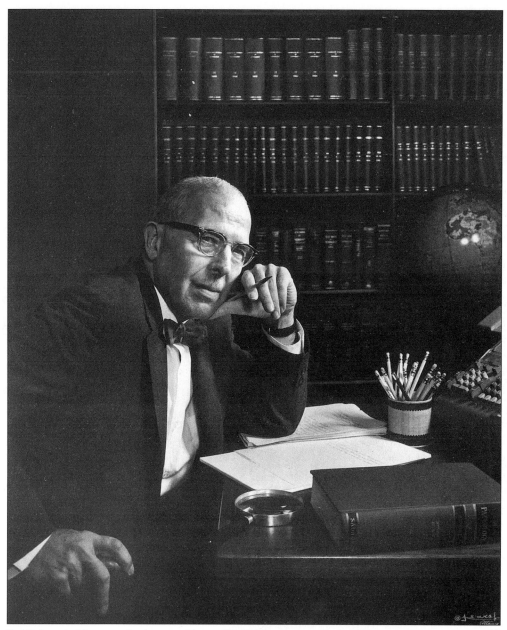

Dr. Robert A. Moore retired as president of SUNY Downstate Medical Center on August 31, 1966. This photograph by world famous photographer Yousuf Karsh hung in the lobby of the university hospital that opened in November of that year. The portrait now hangs in the archives after an extensive renovation of the hospital lobby area.

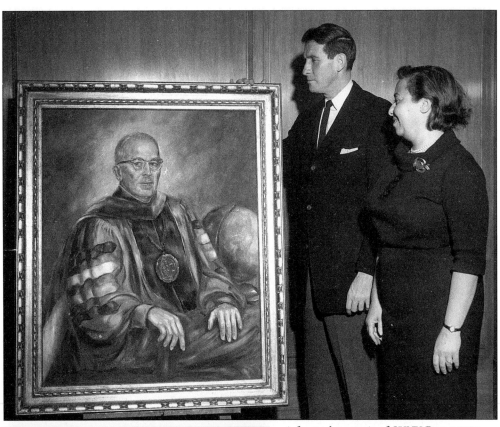

A framed portrait of SUNY Downstate
Medical Center President Robert A.
Moore was presented to the university
community by the Faculty Wives
Association on April 4, 1967. The artist
Norman Garbo and Mrs. Lawrence
Frank, president of the Faculty Wives
Association, take a close look.

Dr. Joseph K. Hill assumed the
presidency of SUNY Downstate Medical
Center on September 1, 1966.

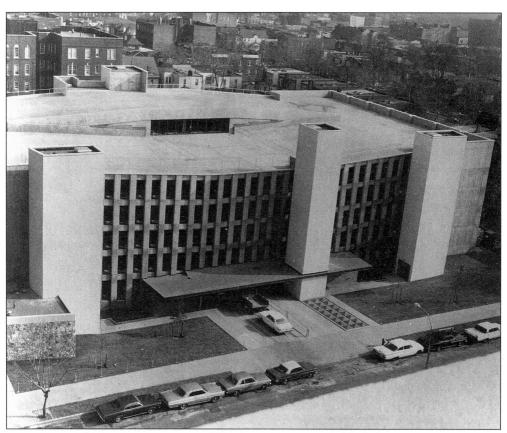

An eight-level parking garage, located on East Thirty-fourth Street behind the Basic Sciences Building, was opened in February 1967. It offered parking facilities for 700 cars and was open to faculty, staff, students, and visitors.

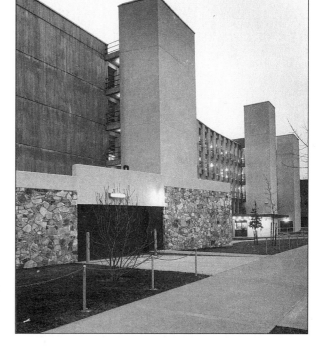

As the campus grew, additional parking facilities became necessary. The state procured various parcels of land surrounding the campus for parking facilities in addition to the parking garage, seen in this street-level view.

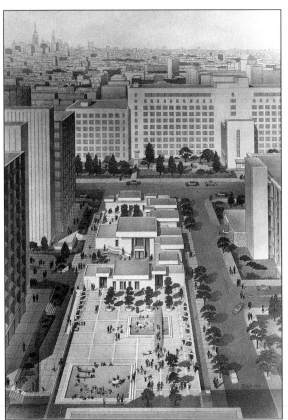

A student center adjacent to the residence halls, shown here as a model, was opened in 1969. The student center is the focal point of recreational, social, and cultural activities on the SUNY Downstate campus. The living room of the medical center provides the opportunity for students, faculty, and staff to meet in an informal setting while engaging in a variety of activities.

The foundation of the student center is being constructed below. The student center has lounges for quiet relaxation, a piano practice room, and several smaller rooms for reading or private conversation. On the more active side, there is a large gymnasium that is also equipped with a stage for use as an auditorium, a pool of near-olympic size, squash courts, game rooms, a universal gym, and a sauna. A later renovation provided for outdoor tennis courts.

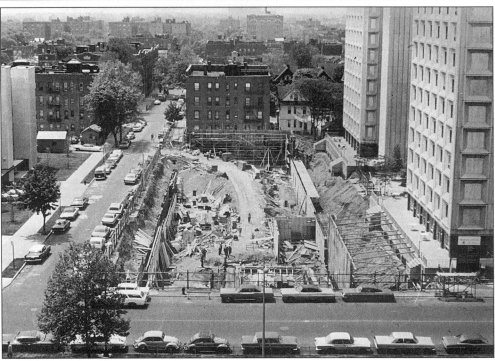

Seen here is the Lenox Road entrance to the student center. The center now contains a café originally called the Rising Sun, a student-operated snack bar, and the Faculty and Student Cooperative Book Store.

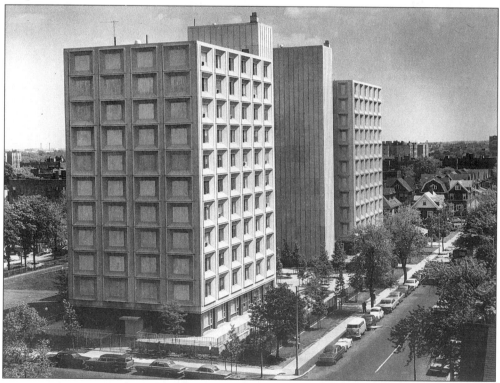

Two 11-story residence halls on New York Avenue behind the Basic Sciences Building opened in September 1964 and February 1965. Each contains 24 double rooms; 48 studio apartments for two people; and 24 one-bedroom apartments that can accommodate two or three single students or a married couple with one or two children. Each residence hall also contains a lounge and a recreation room.

In September 1964, fourth-year medical student Abraham Potolsky and his fianceé, Greta Boxer, a first grade teacher at P.S. 191 in Brooklyn, examine the stove in the kitchenette of the apartment in the new SUNY Downstate Medical Center residence hall. They moved in after their marriage in November 1964.

This interior view was taken from the entryway of an apartment in the residence hall.

This dining and living area was photographed in an apartment in the residence hall.

This spacious bedroom was photographed in an apartment in the residence hall.

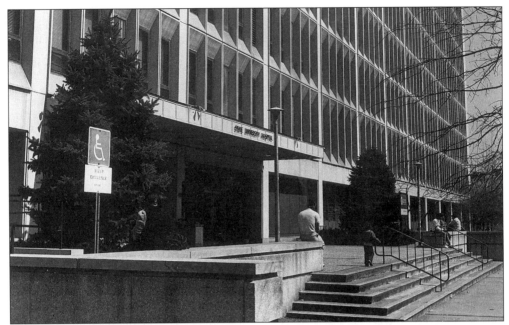

Ground was broken for a 350-bed State University Hospital on February 14, 1963. When completed in 1966, it was one of the nation's most modern and comprehensive medical buildings, combining exciting technological advances with unique provisions for patient care and comfort. A three-story outpatient wing would accommodate 110,000 visits per year; an eight-story research wing connects it to the SUNY Downstate Medical Center's Basic Sciences Building.

Dedication of the new State University Hospital took place on May 5, 1967. Pictured here, Nelson A. Rockefeller, the governor of the State of New York, gave the dedication address. Clifton W. Phalen, chairman of the State University of New York Board of Trustees, presided. An invocation was given by Francis Cardinal Spellman, the archbishop of New York.

A group of medical students and faculty observe a Caesarean section from the dome room in the State University Hospital.

The three-story outpatient wing has its own entrance on the Clarkson Avenue side of the campus. The State University Hospital can be seen in the background with the Basic Sciences Building on the left.

In 1966, SUNY Downstate Medical Center established a College of Nursing, a College of Health Related Professions, and a School of Graduate Studies. Pictured here is the first class of three students in the new College of Nursing. Louise Bussie, R.N., clinical specialist in surgery, demonstrates the insertion of a feeding tube to Carol Hell (center), Arthur Rassias, and Madeleine Schwab. Also looking on is Julia Horgan, R.N., instructor in psychiatric mental health nursing. The "patient" is a teaching mannequin.

With space at a premium, the Colleges of Nursing and Health Related Professions were temporarily housed in the "T" building of Kings County Hospital. It was not until 1991, when the Health Science Education Building was completed, that the colleges moved into their permanent space on the state campus.

Six

THE LAST QUARTER CENTURY

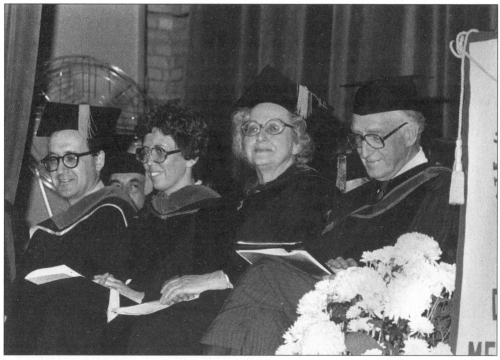

Commencement activities are always happy occasions. Seen at commencement in 1978 are, from left to right, Dr. Albert Kaufman, assistant professor of physiology; Dr. Mimi Halpern, an associate professor of anatomy and cell biology; Dr. Lucy F. Squire, a professor of radiology; and Dr. Francis D. Moore, an Elliott Carr Cutler professor of surgery at the Howard Medical School.

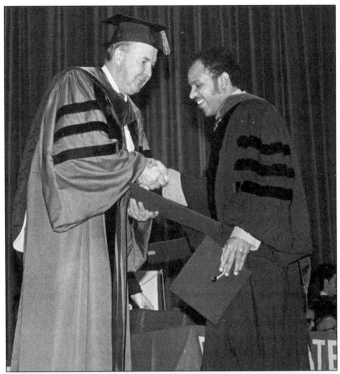

Dr. Calvin H. Plimpton, president of SUNY Downstate Medical Center, congratulates Geoffrey H. Patrice upon receiving his degree in 1978.

Plimpton served as president of SUNY Downstate Medical Center from 1971 to 1979. His official portrait was presented to the SUNY Downstate community on February 11, 1981. The ceremony was held in the President's Board Room before an enthusiastic group of Downstaters, including President-Designate Donald J. Scherl, M.D., and members of the Plimpton family.

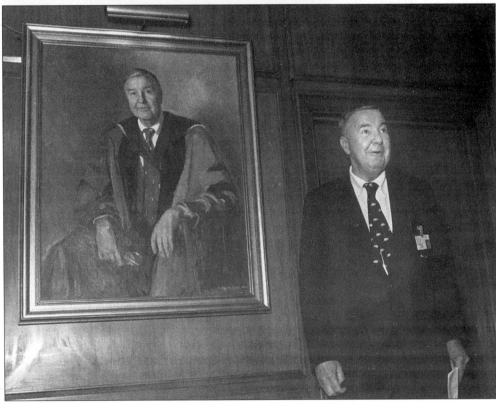

Donald J. Scherl, M.D., assumed the presidency of SUNY Downstate Medical Center in May 1981. He assumed the post from Acting President Stanley L. Lee, M.D. Scherl welcomed the opportunity to become associated with a medical center with so long a history of contributions to the nation in the areas of medical service, research, and health sciences education.

Vice President for Academic Affairs and Executive Dean of Allied Health and Nursing, Jo Ann Bradley, Ed.D., has been with the medical center for nearly 30 years. Her experience with several components of the campus has made her a valuable asset to the administrative body of the campus. She has been unyielding in her commitment and support of the mission of the campus, with particular emphasis on the student body.

Dr. Paul Dreizen, professor of medicine at the College of Medicine and dean of the School of Graduate Studies, has presided over the School of Graduate Studies for most of its existence.

125
YEARS

· SUNY ·
DOWNSTATE
MEDICAL
CENTER

The 125th Anniversary Ball
Downstate Medical Center
of the State University of New York

October 19, 1985
at the
Brooklyn Museum

A milestone in medical education in Brooklyn, SUNY Downstate Medical Center celebrated the 125th anniversary of the College of Medicine in grand style with a dinner dance at the Brooklyn Museum in 1985.

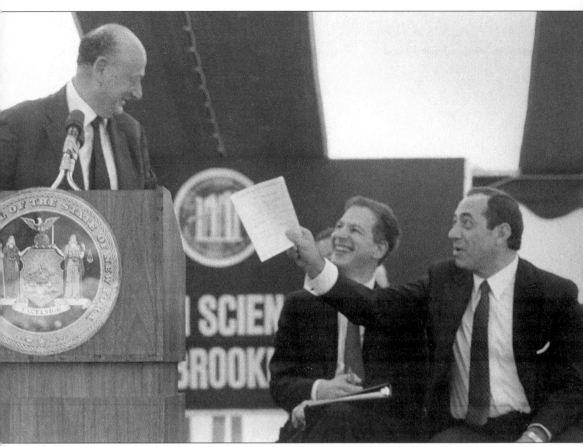

The 1980s saw further campus expansion with the planning and building of the Health Science Education Building. At groundbreaking ceremonies for the new building in 1987, New York City mayor Edward I. Koch (at the podium) chides with New York State governor Mario M. Cuomo while Dr. Donald Scherl, president of the Medical Center, looks on.

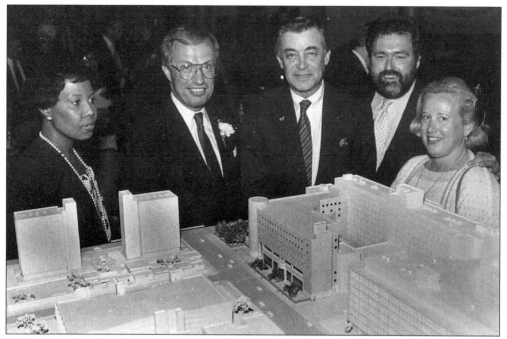

The new Health Science Education Building would provide a permanent space for the College of Nursing and the College of Health Related Professions. It would also give laboratory space for first and second year medical students and a new medical library. The Brooklyn Borough president Howard Golden (center) looks over a model with campus representatives. Golden is flanked by Dr. Jo Ann Bradley, dean of the College of Health Related Professions (left), and Dr. Rita Reis Wizorek, dean of the College of Nursing.

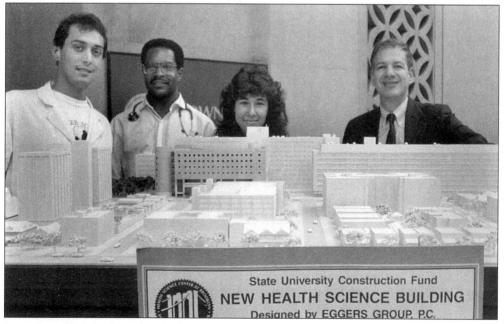

Pres. Donald Scherl (right) looks over a model of the proposed building with student representatives from the College of Health Related Professions and the College of Nursing.

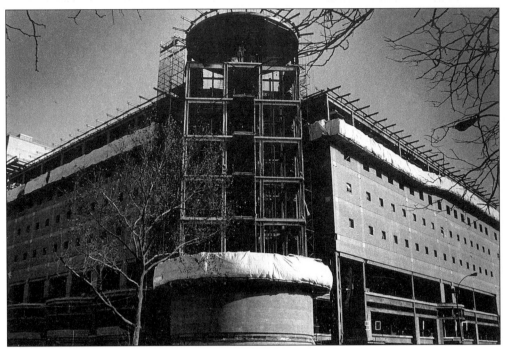

The $54 million Health Science Education Building nears completion on the corner of Lenox Road and New York Avenue.

**Opening New Doors
for Health Science Education**

Opening Ceremonies
The Health Science Education Building

The State University of New York
Health Science Center at Brooklyn

Wednesday, January 29, 1992
Health Science Education Building Auditorium

Opening ceremonies for the new building took place on January 29, 1992. It took several months for the various constituents to move into the new facility. The College of Nursing and the College of Health Related Professions would leave the "T" building on the grounds of the Kings County Hospital Center for their first permanent location since being established in the 1960s.

An additional portal to the Health Science Center campus, the "395" entrance is used by many students and staff. The new building is connected to the older Basic Sciences Building on several levels, allowing greater access to the new facilities. It is also directly across the street from the student center and residence halls.

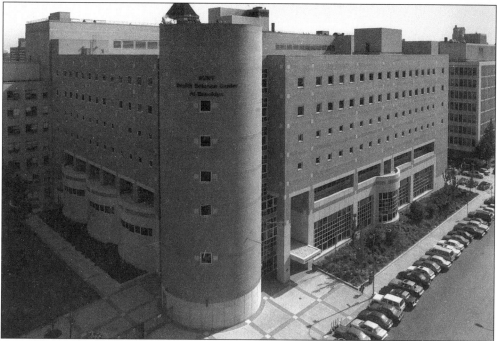

The Health Science Education Building has become a modern-day icon representing the SUNY Downstate Medical Center campus. The Health Science Center community associates the new building with the evolving campus' mission and commitment to progress in medical and allied health education, research, and health care.

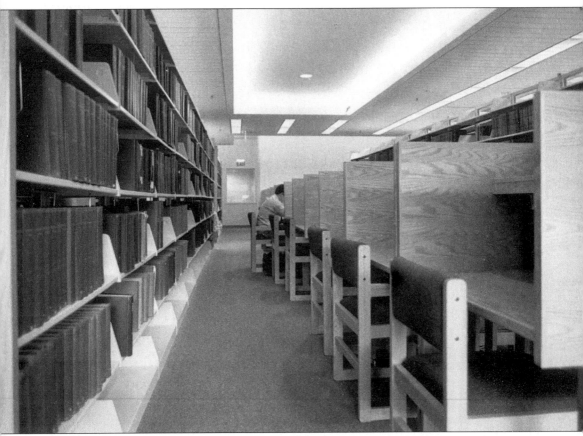

The Medical Research Library of Brooklyn was the first to move into the new facility. Having moved its collections from several locations, it took almost two months to complete the relocation. The library now enjoys modern amenities such as air conditioning, a new learning resource center, movable shelving in its storage area, adequate seating for the student body, and an integrated computerized library system.

In 1988, Dr. Donald Scherl (center) accepted a $1 million pledge and a $200,000 gift from Dr. and Mrs. Clarence Dennis in fulfillment of their promise to provide an endowment for a chair in the Department of Surgery. A past chair of the Department of Surgery, Dennis performed the first successful open-heart operation in New York State on June 30, 1955.

Dr. Jo Ann Bradley (left) acknowledges Dr. and Mrs. Dennis's gift at a reception in their honor held in the atrium of the Health Science Education Building.

Dr. Donald Scherl appears at a panel discussion with civil rights activist and former mayor of Atlanta, Andrew Young.

Tennis great and champion of civil liberties, Arthur Ashe inaugurated the Arthur Ashe Institute for Urban Health at the Health Science Center on December 3, 1992. It was one of his last public appearances. With the formation of the the institute, the Health Science Center entered a new era. The institute is a focus for the study of urban health care issues and an enduring tribute to the late Mr. Ashe and to his belief that equal access to health care is a civil right.

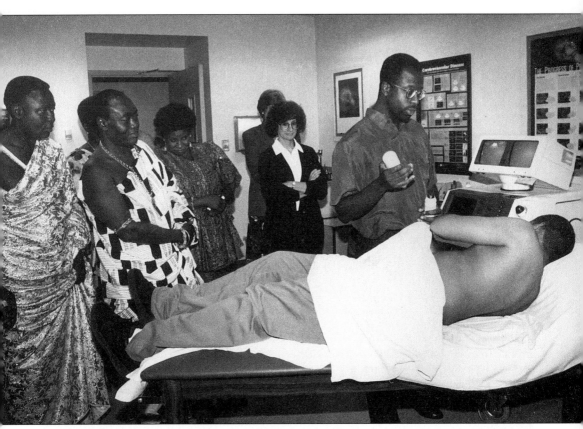

On August 24, 1993, the Health Science Center was visited by the Okyenhene, Osagyefo Nana Kuntukununku II, and his entourage. Pictured here, they are observing assistant professor and clinical coordinator Adrian Anthony of the Diagnostic Medical Imaging Program as he demonstrates imaging techniques in the DMI laboratory. Students take on the role of patients in the program's teaching laboratory. The DMI program at SUNY Downstate Medical Center was the first program in the United States to offer a Bachelor of Science degree with a major in diagnostic medical sonography.

Dr. Richard H. Schwarz (left) enjoys mingling with students at orientation activities. Schwarz, the former chairman of the Department of Obstetrics and Gynecology, was also provost and vice president for clinical affairs of the College of Medicine. He also assumed the post of acting president upon Dr. Donald J. Scherl's retirement.

Orientation activities include informative lectures, get-togethers, luncheons, barbeques, and the annual Circle Line boat ride around Manhattan. Pictured here on the 1993 boat ride, Meg O'Sullivan (right), director of student life, surrounds herself with members of the Class of 1997. Included among them are Jennifer K. Wright (left) and Andrew P. MacKenzie (second from left).

Students from the Class of 1997 enjoy
outdoor orientation activities in the courtyard
of the student center.

Russell L. Miller, M.D., assumed the post of
president from Dr. Schwarz in August 1994.
Schwarz had held the post of acting president
from the time of Scherl's retirement.

The College of Medicine held its first annual White Coat Ceremony on August 17, 1995, while presenting the Class of 1999. The White Coat Ceremony, a special program for students entering medical school, is designed to inspire a psychological contract for empathy and professionalism in medicine from the first day of medical training.

Ben Carson, M.D. (center), renowned pediatric neurosurgeon at John Hopkins University Medical Center, was guest speaker at the College of Medicine's inaugural White Coat Ceremony. On the left is Dr. Arnold P. Gold, the president of the Arnold P. Gold Foundation and the initiator and supporter of white coat ceremonies at medical schools across the country. Standing on the right is Dr. Russell I. Miller, president of SUNY Downstate Medical Center.

Students from the Class of 1999 don their white coats.

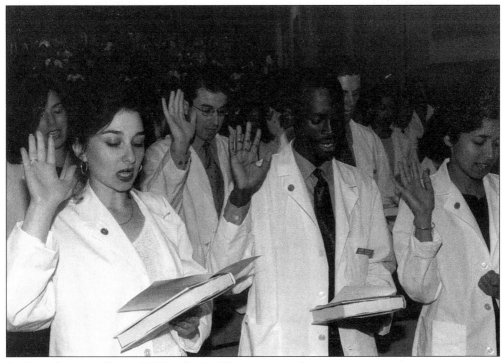

Students from the Class of 1999 take the Hippocratic oath.

Eugene B. Feigelson, M.D., assumed the post of interim president upon Dr. Russell I. Miller's retirement. Carrying out the duties of the top office of the medical center, he also retained the post of chairman of the Department of Psychiatry, the duties of senior vice president for biomedical education and research, and the responsibilities of dean of the College of Medicine.

The faculty of the School of Graduate Studies celebrates student achievements at their annual Research Day. Seen here, from left to right, are Alan R. Gintzler, Ph.D., professor of biochemistry and psychiatry in the College of Medicine and of Biochemistry and Neural and Behavioral Sciences, School of Graduate Studies; Susan Schwartz-Giblin, Ph.D., dean of the School of Graduate Studies and professor of Neurology; and William McAllister, Ph.D., professor and chairman of the Department of Microbiology and Immunology.

This photograph was taken at the School of Graduate Studies annual Research Day in 1990. Graduate students explain their research by presenting poster exhibits to colleagues, faculty, and interested staff members. Awards are also given for several categories of excellence.

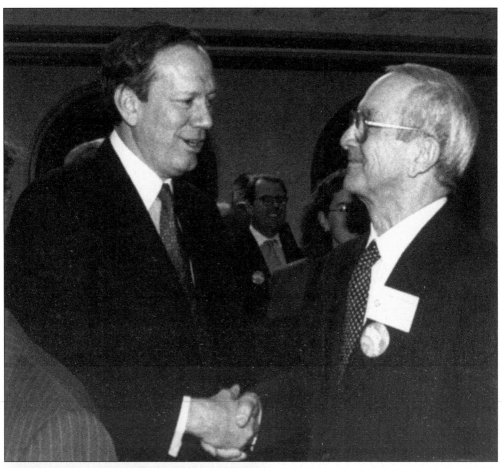

Dignitaries have always visited the Health Science Center and supported special event programs. The campus also holds an annual legislative forum to inform members of the New York State Legislature of the accomplishments and future needs of the facility. Here, Interim President Dr. Feigelson greets New York State Gov. George Pataki at a SUNY Downstate event.

Dr. Eli Friedman (right) appears with Dr. Lawrence Altman, who was a guest lecturer at the Health Science Center's 1996 Alpha Omega Alpha lecture series.

Match Day, an annual event held in March, is when fourth-year students in medical schools across the country learn where they have been placed to intern and carry out their residency programs. Here, three happy seniors celebrate Match Day in 1999. Special souvenir champagne glasses are presented to students for the event.

With only weeks left in their undergraduate education, students celebrate with champagne during a past Match Day. Held in ceremonial fashion, students nervously open their envelopes to reveal where they will spend their next phase of medical education.

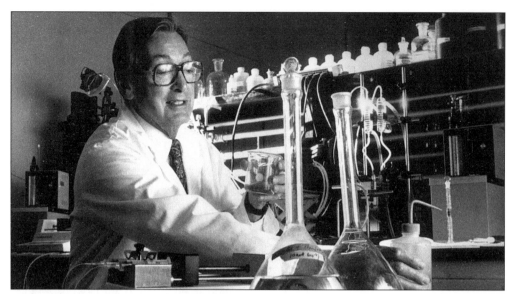

On October 12, 1998, Dr. Robert Furchgott was awarded the Nobel Prize in Physiology and Medicine for his discovery of the role that nitric oxide plays as a signaling molecule in the cardiovascular system. Furchgott shared the prize with two other researchers: Ferid Murad of Houston and Louis J. Ignarro of Los Angeles. Furchgott, a distinguished professor emeritus of pharmacology and former chairman of the Department of Pharmacology, is SUNY Downstate Medical Center's first Nobel Laureate as well as the first Nobel Laureate within the SUNY system to have conducted research on a SUNY campus.

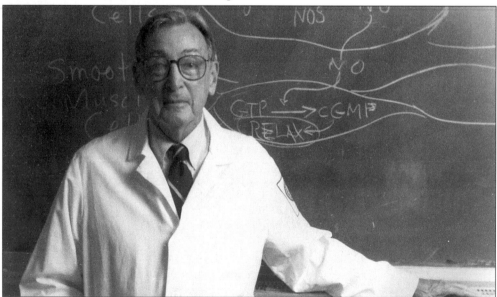

In 1980, Furchgott reported his discovery of the obligatory role of endothelial cells in the relaxation (vasodilation) of arteries by acetylcholine and related muscarinic agonists. He demonstrated that the relaxation resulted from release of a labile factor (later called endothelium-derived relaxing factor, or EDRF) from the stimulated endothelial cells. This novel finding was followed by the discovery in his own and other laboratories that many vasodilators, both endogenous substances and drugs, act by stimulating release of EDRF.

Dr. Robert Furchgott independently showed that EDRF acts by stimulating the enzyme guanylate cyclase in the vascular smooth muscle cells, leading to an increase in cyclic GMP, which mediates relaxation. He also found hat photorelaxation of blood vessels is mediated by an increase in cyclic GMP. In 1986, he presented evidence for his independent proposal that EDRF is nitric oxide, and that the neuro-transmitters released by NANC nerves may also be nitric oxide. It was for this body of work that Furchgott received the Nobel Prize. Shown is a model of the nitric oxide molecule rendered in a computer graphic by John Zubrovich of the Department of Biomedical Communications.

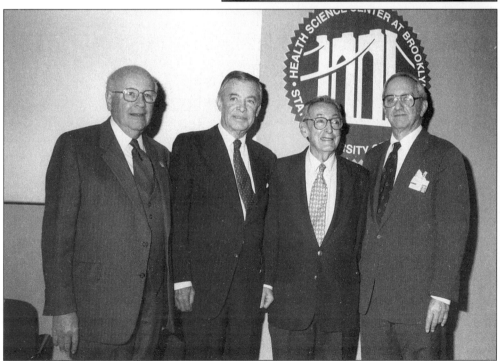

These dignitaries, from left to right, are Thomas F. Egan, chairman of the State University of New York Board of Trustees; Brooklyn Borough President Howard Golden; Dr. Furchgott; and Eugene B. Feigelson, M.D., interim president of SUNY Downstate Medical Center.

John C. LaRosa, M.D., was appointed SUNY Health Science Center's new leader on September 1, 1999. LaRosa was previously the chancellor of the Tulane University Medical Center. He will guide SUNY Downstate Medical Center into the 21st century with its medical school (now the 15th largest in the United States), its university hospital, its College of Nursing, its College of Health Related Professions, and its School of Graduate Studies. He has set new goals in technology and challenging curriculum-related issues, as well as developing new trends in health care for the people of Brooklyn and New York State.

126

With 140 years of experience, SUNY Health Science Center at Brooklyn will surely continue to grow and contribute to the advancement of medicine, while recognizing the needs of Brooklyn's varied population. To quote the *Brooklyn Daily Eagle* of July 25, 1860, "We chronicled in March last the opening of the Long Island College Hospital. From the well-known ability and energy, and more than all from the self-sacrificing spirit of those at its head, we anticipated the most favorable results. [We now feel that] we are justified in saying . . . that Brooklyn can boast of having a medical college within its borders second to none in the ability of its faculty and its opportunities for imparting a thorough education."

Bibliography

Chesley, L.C. *Evolution of the Department of Obstetrics and Gynecology at Downstate, 1860–1980.* Brooklyn, New York: Downstate Medical Center, 1981.

Curran, J.A. "The Tradition of Austin Flint and Alexander Skene at 'Long Island.'" *Minnesota Medicine*, 48:1719–22: 1965.

Donaldson, B.M. *The Long Island College Hospital and Training School for Nurses, 1858-1883-1933.* Brooklyn, New York, Willis McDonald & Company, 1933.

Downstate Medical Center (New York). *Medical Education in Brooklyn; The First Hundred Years, 1860–1960.* Brooklyn, New York, 1960.

Draper, W. "Historical Development of Medicine in Brooklyn." *New York State Journal of Medicine*, 71:776–86: 1971.

Draper, W. "Merger in Brooklyn: the Academy of Medicine and the Downstate Medical Center Libraries. History of the Academy of Medicine of Brooklyn Library." *Bulletin of the Medical Library Association*, 51:168–75: 1963.

Edson, J.N. *Brooklyn First: a Chronicle of the Long Island College Hospital, 1858–1990.* Brooklyn, New York: Long Island College Hospital, 1993.

Edson, J.N. "History: the Great Reminder. The Relationship between the Long Island College Hospital and the State University of New York Health Science Center at Brooklyn." *New York State Journal of Medicine*, 92:392–4: 1992.

Eggerth, A.H. *The History of the Hoagland Laboratory.* Brooklyn, New York: The Hoagland Laboratory, 1960.

Flexner, A. *Medical Education in the United States and Canada. A Report to the Carnegie Foundation for the Advancement of Teaching.* New York: the Foundation, 1910.

Furman, Dorothy. *The History of the Long Island College Hospital School of Medicine, 1857–1940.* Brooklyn, New York: Long Island College Hospital, 1940.

Joint Committee on Graduate Education of the Medical Society of the County of Kings and the Long Island College Hospital. "The Brooklyn Extension Plan. The Story of the Graduate Education Movement in Kings County." *Long Island Medical Journal*, 17:364–7: 1923.

Kovacs, H. "Outstanding Brooklyn Medical Libraries Merge." *Bulletin of the Medical Library Association*, 50:613–4: 1962.

Kovacs, H. "Merger in Brooklyn: the Academy of Medicine and the Downstate Medical Center Libraries. Present and future plans." *Bulletin of the Medical Library Association*, 51:176–80: 1963.

Raymond, J.H. *History of the Long Island College Hospital and its Graduates; Together with the Hoagland Laboratory and the Polhemus Memorial Clinic.* Brooklyn, New York: Association of the Alumni, 1899.

Schroeder, W. "History of the Ambulance System in Brooklyn, New York." *Brooklyn Medical Journal*, 16:381–95: 1902.

Shands, A.R. *The Early Orthopaedic Surgeons of America.* St. Louis: Mosby, 1970.

State University of New York College of Medicine at New York City Alumni Association. *History of the Long Island College Hospital, Long Island College of Medicine, and the State University of New York College of Medicine at New York City. Alumni Association Highlights, 1880–1955, and Biographies of Graduates, 1900–1955.* Brooklyn, New York: Association of the Alumni, 1955.

Welton, T.S. "The Long Island College Hospital: the College." *Long Island Medical Journal*, 17:374–6: 1923.

Winfield, J.M. "The Long Island College Hospital." *Long Island Medical Journal*, 4:225–8: 1910.